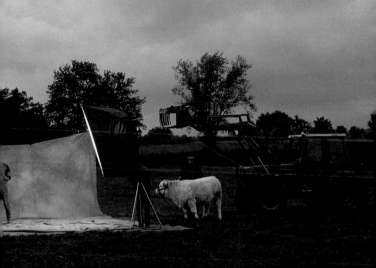

KU-021-017

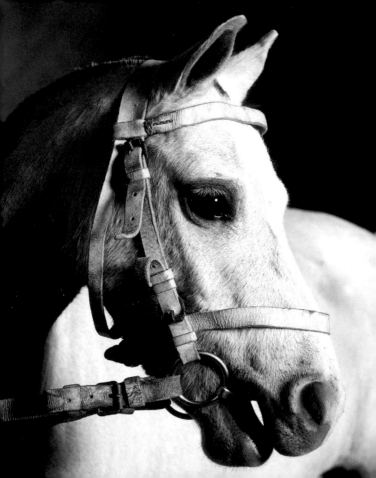

Good Breeding

PHOTOGRAPHS BY YANN ARTHUS-BERTRAND

ESSAY BY CLAUDE MICHELET

WITH TECHNICAL ASSISTANCE FROM FRANCE UPRA SÉLECTION,
THE INSTITUT NATIONAL AGRONOMIQUE PARIS-GRIGNON,
AND THE INSTITUT DU CHEVAL

Harry N. Abrams, Inc., Publishers

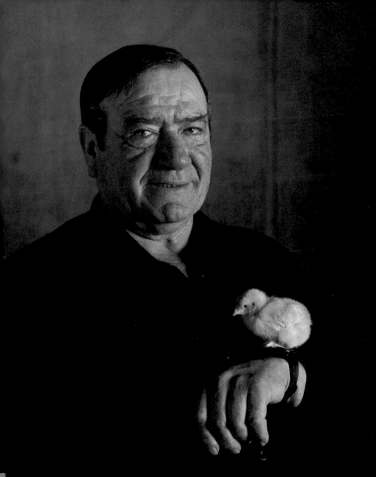

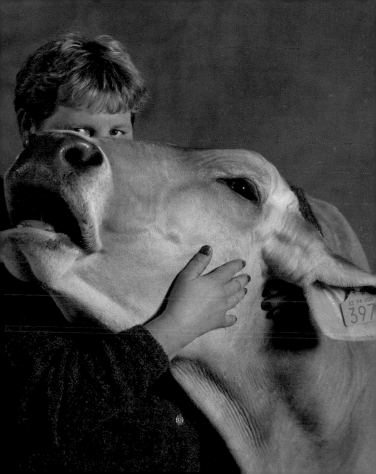

ABONDANCE
Farandole (daughter of
Cristóbal and Brunette),
5 years old, with his owner,
Noël Deloche, of Thônes,
France
(*Agricultural Show, Paris*)

Preceeding left page:
André Salesses, known as
"Dédé," has been attending
the Paris Agriculture Show
for 35 years in his capacity
as animal transporter
(*Agriculture Show, Paris*)

Preceeding right page:
BROWN SWISS COW
Jeunesse (daughter of
Admiral and Caille), four
years old, with her owner,
Isabelle Portal de
Dalmayrac
(*Agriculture Show, Paris*)

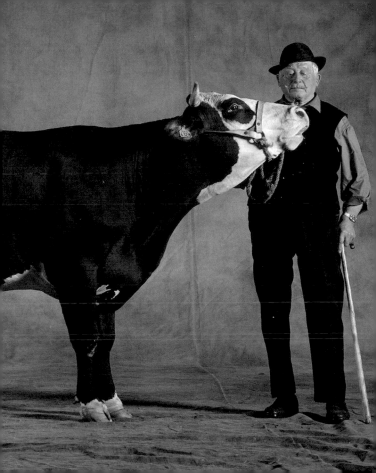

**GLOUCESTER
OLD SPOT PIG**

Princess; presented by
Sarah Bagnall, age nine;
owned by Anne Uglow
(Royal Show, England)

Overleaf:
GASCON COW

Anaïs, and her calf; owned
by Christian Asna
(Agriculture Show, Paris)

10

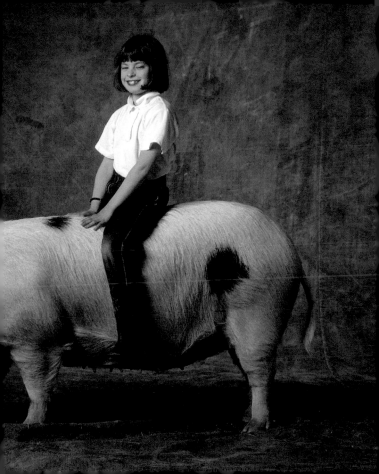

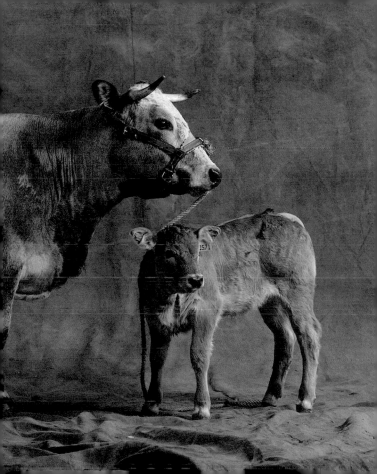

NORTHERN FRENCH DRAFT HORSE

Eva de Germignies (daughter of Mico and
Vaillante de Germignies), seven years old,
owned by René Dujardin and presented
by Louis Deltour
(Agriculture Show, Paris)

Overleaf:
SHIRE MARE

Stanley House Duchess and her colt Stanley
House John Bull, presented by Anne Hull
of Pad Stud Farm, Lancashire, England
(Royal Show, England)

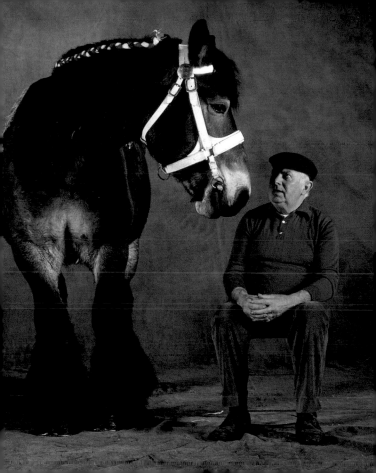

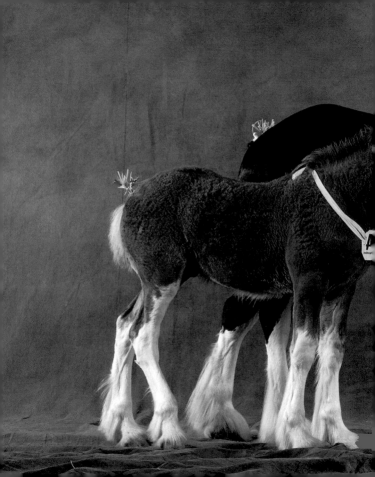

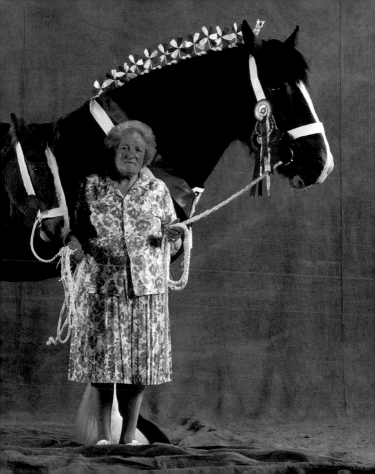

SOUTHDOWN SHEARLING EWES

Presented by Sarah Mitchell, D. Richard
Randall, and their son, Michael, of Ventnor,
England
(Royal Show, England)

Overleaf:

ARGENTINE CRIOLLO MARE

Chake Coronilla 1280 (daughter of Che
Chajari and Chake Bofetada), six years old;
presented by Ramon Mendez; owned by Mr.
and Mrs. Matho Garat, Cabaña "La Estrella"
(La Rural, Buenos Aires)

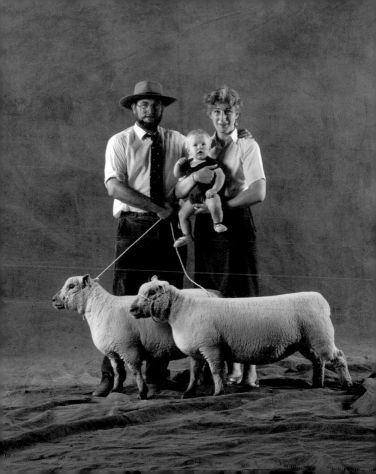

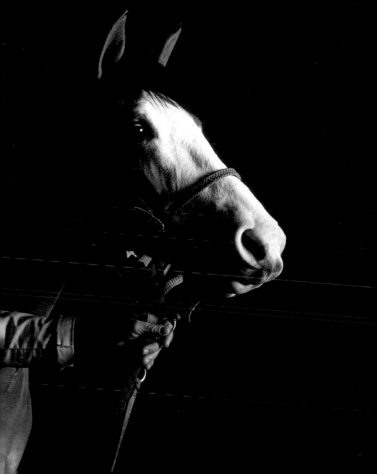

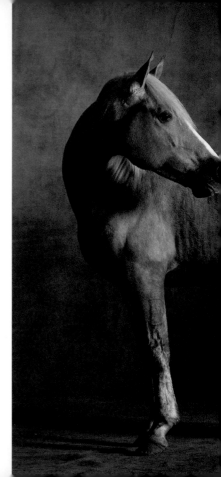

**ARGENTINE
CRIOLLO STALLION**
Miriju Noche Mala,
seven years old; owned by
Mr. Duchini, Cabaña "La
Margarita," in Ranchos,
Argentina
(*La Rural, Buenos Aires*)

Overleaf, left:
BELGIAN BLUE BULL
Astucieux du Moulin
de Rance; owned by
B. E. Newton
(*Royal Show, England*)

Overleaf, right:
HEREFORD BULL
Derby, presented by
Clive Richards
(*Royal Show, England*)

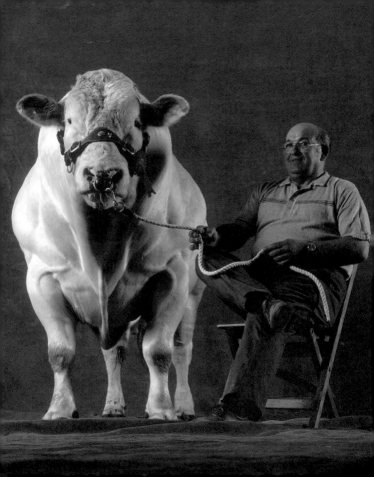

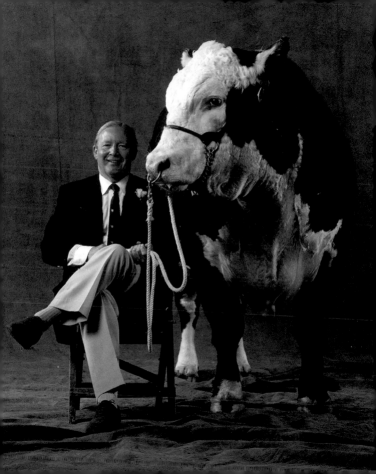

LARGE WHITE BOAR

Bagnères de Poulard (son of Actif de Poiville), four years old and weighing 1,105 pounds, with his owner, Henry Bordes, of Poulard, France *(Agriculture Show, Paris)*

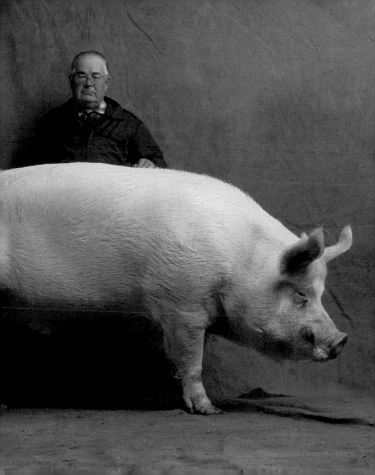

PERCHERON STALLION

Three Holes Grenadier,
presented by Richard
Johnson of Lode Hall–
Three Holes, Wisbech,
Cambridgeshire, England
(Royal Show, England)

Overleaf:
AUXOIS MARE

Duchesse (daughter of
Ulysse and Urgente),
seven years old, 1997 breed
champion, with her owner,
Abel Bizouard, of Sussey,
France
(Agriculture Show, Paris)

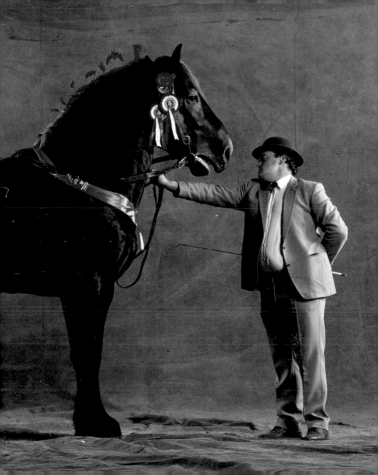

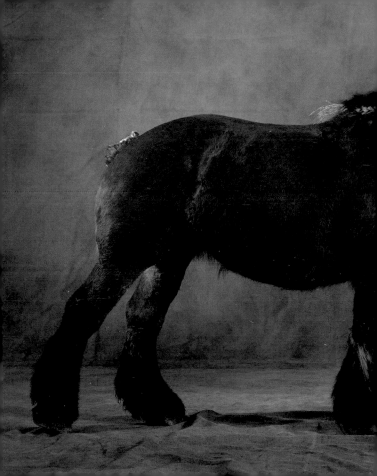

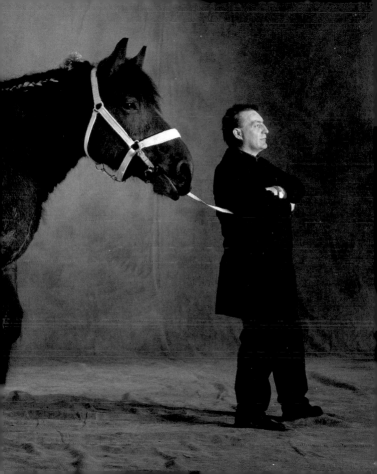

LARGE WHITE PIG

Liskeard Beautiful;
presented by Ben, son of
Mr. and Mrs. Collings,
the owners, of Cornwall,
England
(Royal Show, England)

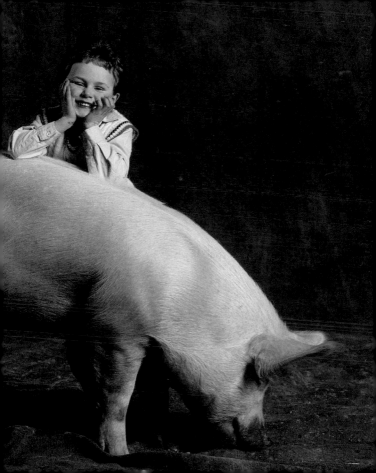

NORMAN, OR WESTERN WHITE, PIG

Hellène (daughter of Fonceur and Groseille), with her owner, Claude Doyennel, of Caumont-L'Éventé, France (*Agriculture Show, Paris*)

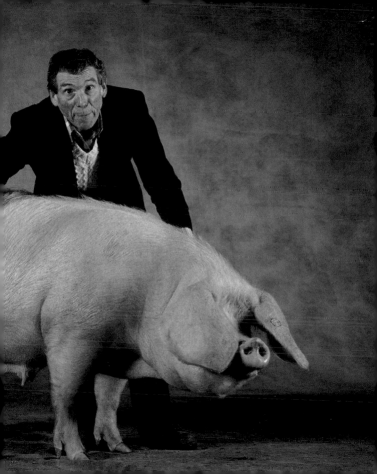

BLONDE D'AQUITAINE BULL

Charly (son of Ulysse and Tornade), six
years old, with his owner, Alain Moniot,
of Renève, France
(Agriculture Show, Paris)

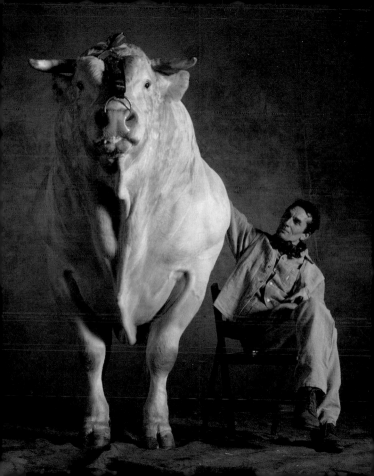

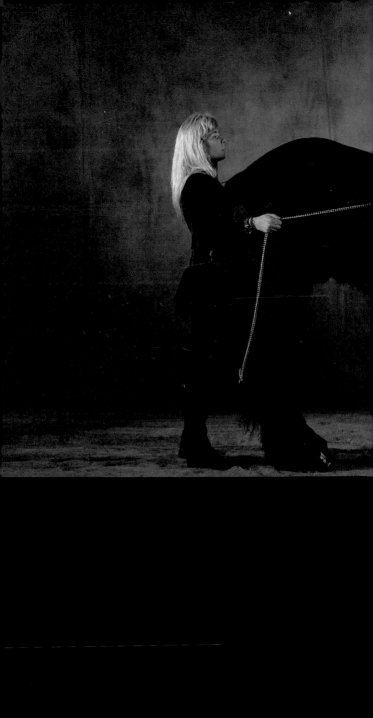

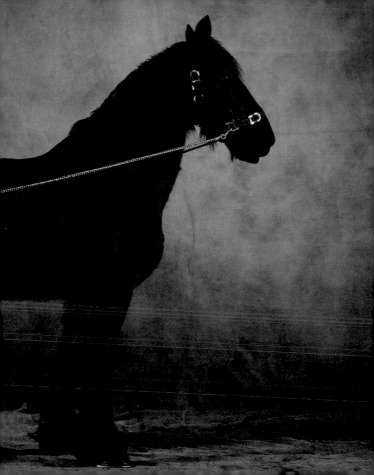

Preceding pages:

FRIESIAN HORSE

Koert (son of Walter),
eleven years old; presented
by Ann Zagradsky; owned
by Philippe Harcourt, of
Fumichon, France
(Agriculture Show, Paris)

CHAROLAIS BULL

Jojo (son of Dakar and
Guinée), four years old,
accompanied by his owners,
Anne and Jean-Marc
Michoux of Villeneuve-
sur-Allier, France
(Agriculture Show, Paris)

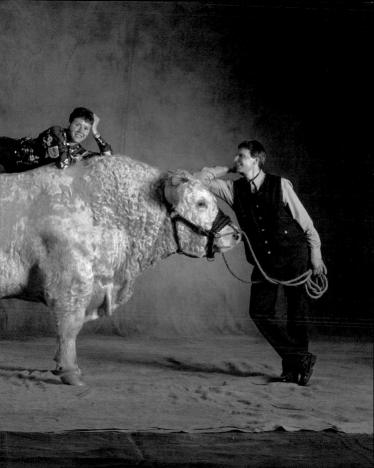

BLONDE D'AQUITAINE BULL

Gardon (son of Tonnerre and Coquine),
seven years old, at 3,588 pounds the heaviest
bull at the 1998 Agriculture Show; presented
by Jules Claverie; owned by Maurice Lar-
roque, of Fosseret, France
(Agriculture Show, Paris)

Overleaf:
VOSGES COW

Yvette (daughter of Gaillard and Cathy),
six years old, presented by her owner Jean-
Daniel Wehrey, of Breitenbach, France
(Agriculture Show, Paris)

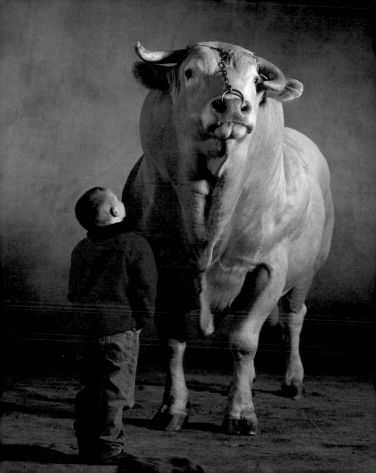

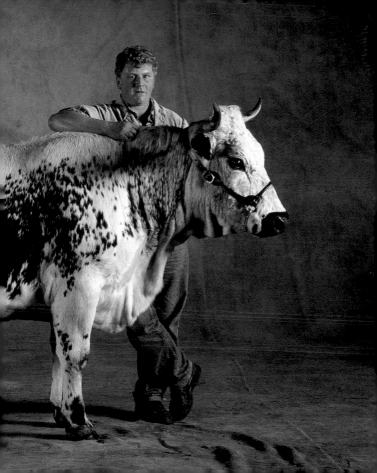

TARENTAISE COW

Bleuet, five years old,
with her owner, Maurice
Collomb, breeder in
Valezan, France
(*Agriculture Show, Paris*)

Overleaf:
ARDENNES STALLION

Hercule (son of Sultan
de Saint-Jacques and
Princesse), two years old,
with his owner, Émile
Peupion, breeder in
Lachambre, France
(*Agriculture Show, Paris*)

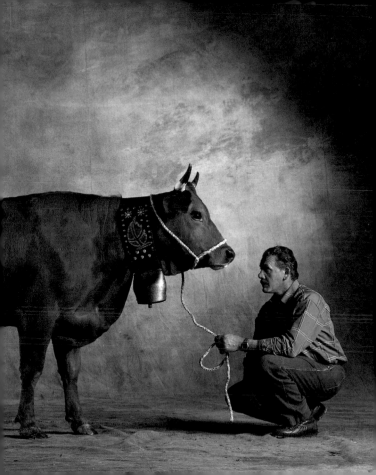

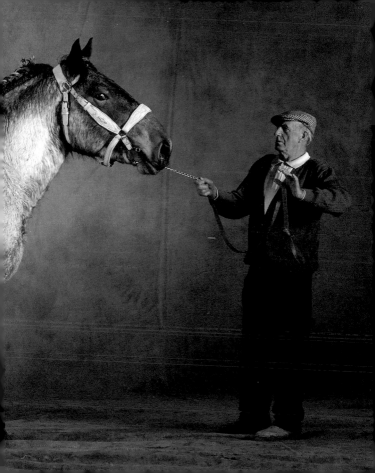

SHROPSHIRE RAM

Sidedowns Horatio, with his owner, John H. Bowles, of Exeter, Devon, England (*Royal Show, England*)

Overleaf:
SUFFOLK EWE

Ready to be sheared; owned by S. R. and Y. E. Eaton, of Beech House, England (*Royal Show, England*)

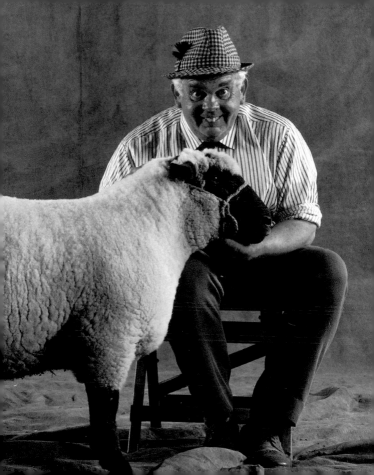

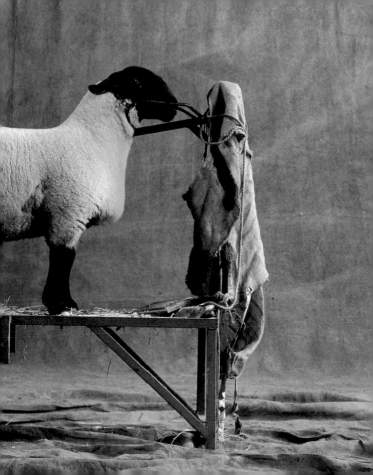

AUBRAC BULL

Joyeux (son of Exquis and Altesse), four years old and weighing 2,695 pounds; owned by Guy Barriol, breeder in Cezens, France (*Agriculture Show, Paris*)

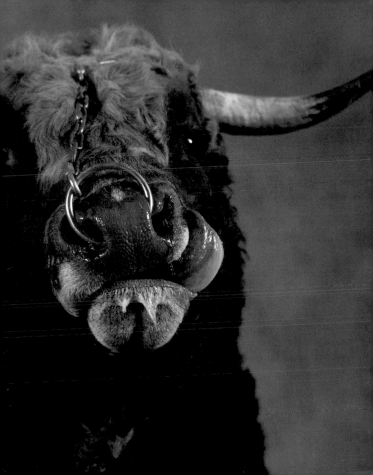

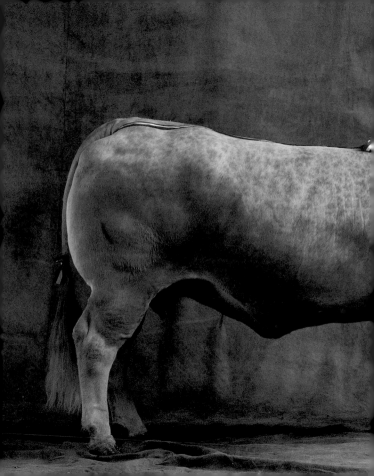

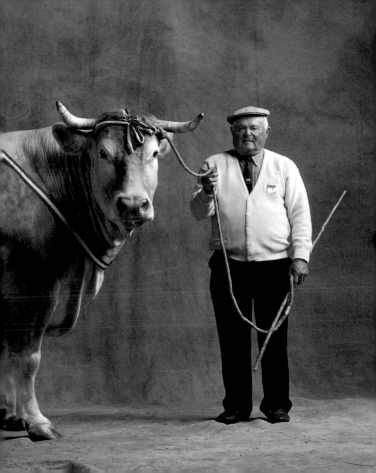

Preceding pages:

BLONDE D'AQUITAINE COW

Ula (daughter of Maestro and Juliette), seven years old, with her owner, Fernand Descazeaux, breeder at Mas Grenier, France
(Agriculture Show, Paris)

AUSTRALIAN MERINO RAMS

Presented by their owners, Emilio Jorge and his wife, Susana Ferro, of Cabaña "La Adela"
(Valdés Peninsula, Chubut Province, Argentina)

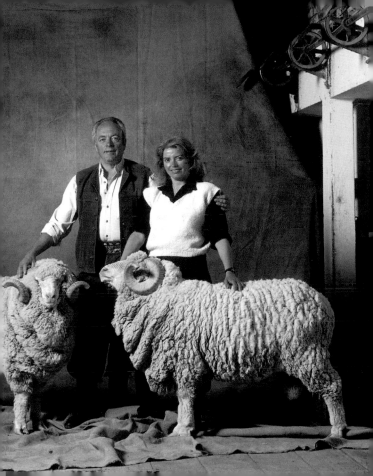

Preceding pages:

**ARGENTINE
CRIOLLO HORSE**

Ayacucho Coscorrón,
with horse trainer Martín
Hardoy
(La Rural, Buenos Aires)

DELLE LANGHE RAM
(Agriculture Show, Paris)

HAMPSHIRE RAM

Presented by Georges Dubois, breeder;
raised in Liginiac; owned by Mrs. Metzger
(Agriculture Show, Paris)

Overleaf:

NORMANDE COW

Baguée (daughter of Newgate and Ondée),
eight years old, with her young owner, Katia
Lecomte, of Saint-Jean-des-Échelles, France
(Agriculture Show, Paris)

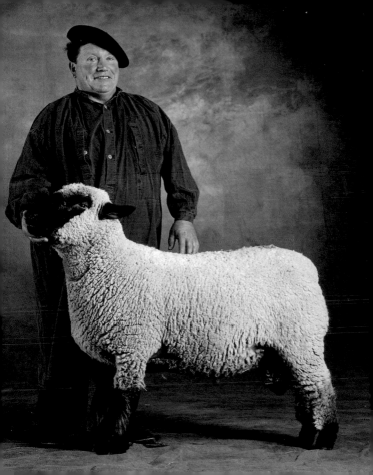

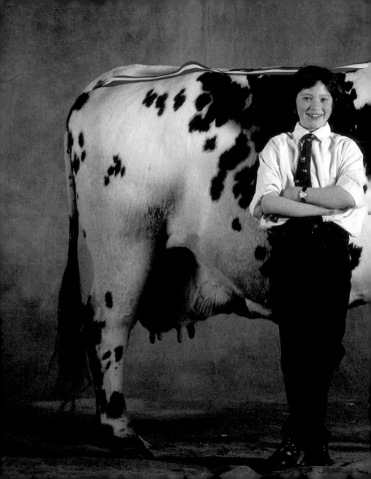

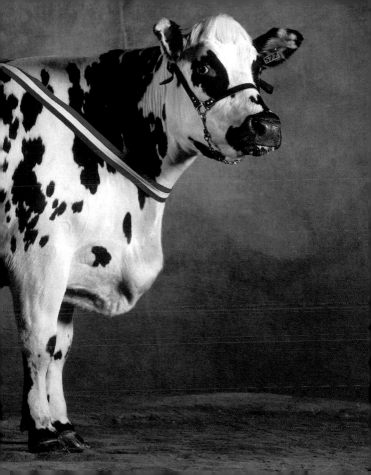

PIEDMONT BULL

Celso (son of Bauli and Olympia);
weighing 2,715 pounds
(*Agriculture Show, Paris*)

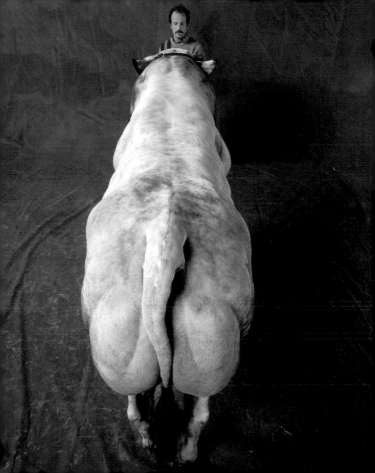

BELGIAN BLUE-WHITE BULL

Vicomte de Somme (son of Nastade du
Fond de Bois and Séverine de Somme);
presented by Mr. Albert; owned by the
Haliba Center for Artificial Insemination,
Mons, Belgium
(Agriculture Show, Paris)

Overleaf:

BLONDE D'AQUITAINE BULL

Gardon (son of Tonnerre and Coquine),
seven years old, at 3,588 pounds the heaviest
bull at the 1998 Agriculture Show; presented
by Marie Thérèse Valery; owned by Maurice
Larroque, of Fousseret, France
(Agriculture Show, Paris)

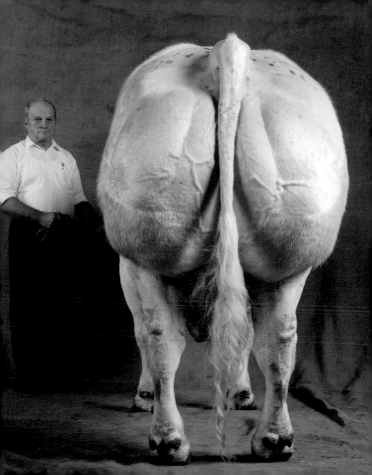

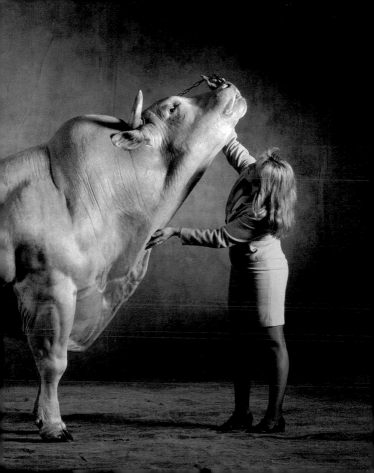

NORMAN, OR WESTERN WHITE, PIG

Java (daughter of Hellène), five years old,
with her owner Claude Doyennel,
of Caumont-L'Éventé, France
(Agriculture Show, Paris)

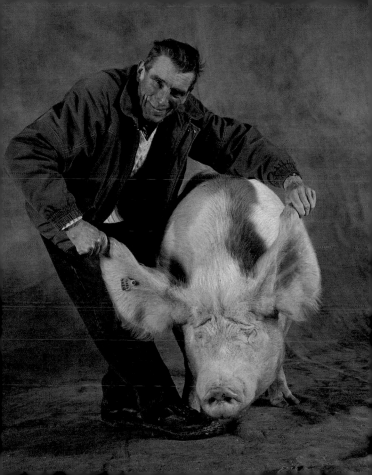

SHORTHORN COW

Gorri Grande 253 (daughter
of X 253 and Fortin Grande
Blossom); presented by
Ramon Ignacio Torres;
owned by Dolorès Ahumada
de Roca, Cabaña "La
Dolores"
(La Rural, Buenos Aires)

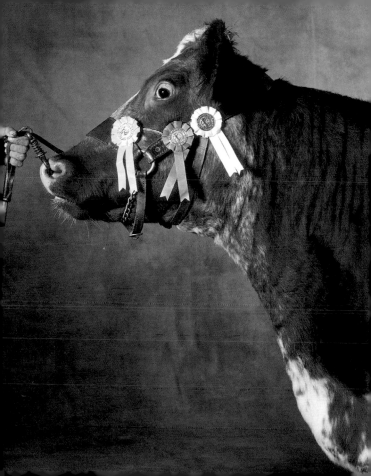

AYRSHIRE COW

Middle Cissie, with her owner,
William Whiteford, of Carlisle, England
(Royal Show, England)

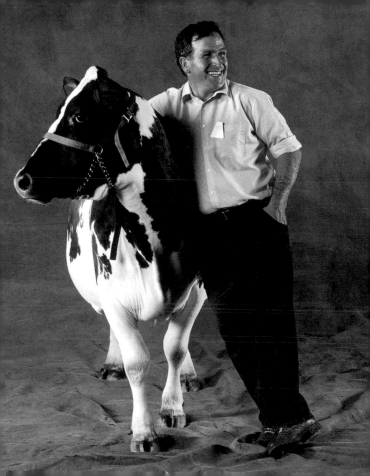

SALERS BULL

Germain (son of Danton and Blonde), four years old, with his owner, Gérard Pouget of Riom-ès-Montagnes, France
(*Agriculture Show, Paris*)

Overleaf:
AURE ET SAINT-GIRONS COWS

Victoire, called Soubagne, and Durbane, called Houchette, harnessed by their trainer, Olivier Courthiade; owned by the Méras Farm in Nescus, France
(*Agriculture Show, Paris*)

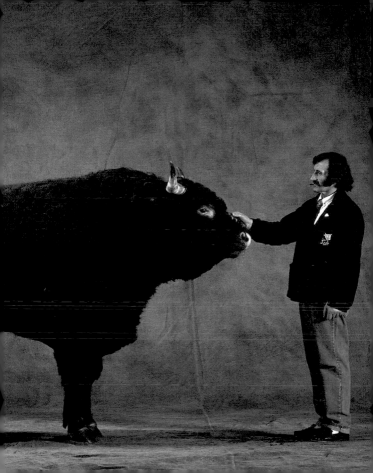

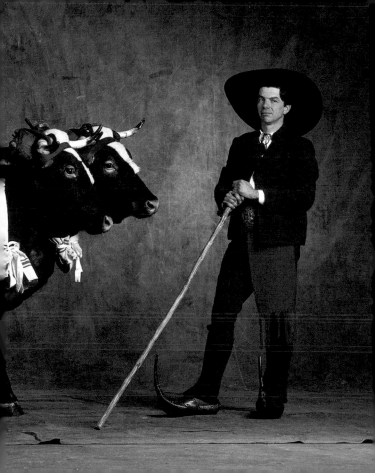

NANTES BULL

Guenrouet (son of Rium and Fauvette), three years old; presented by Régis Fresneau; owned by Rémy Douet, of the Domaine de Bois-Joubert, France (*Agriculture Show, Paris*)

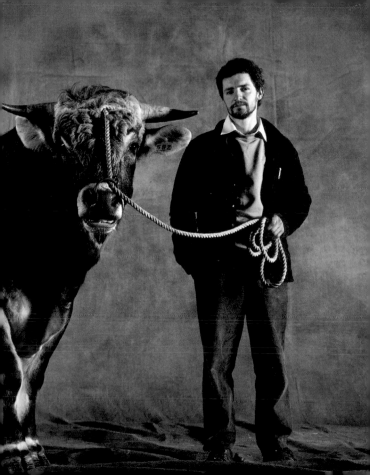

JERSEY COW
Éole (daughter of Royal
and Tyrolle), six years old;
presented by Michel and
Marie-Thérèse Pineau;
owned by Philippe Guil-
loteau, breeder in Gros-
breuil, France
(Agriculture Show, Paris)

Overleaf:
PRIM'HOLSTEIN COW
Étoile (daughter of Mel-
wood and Chadenn), five
years old, with her breeder,
René Louvet-Chazottes of
Bibal, France
(Agriculture Show, Paris)

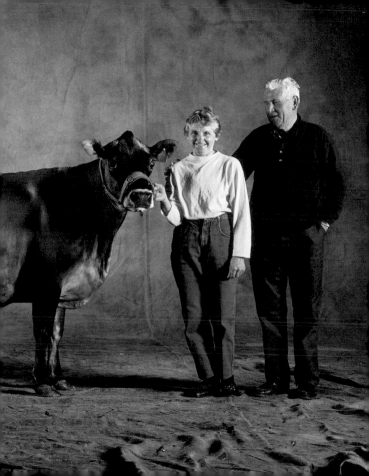

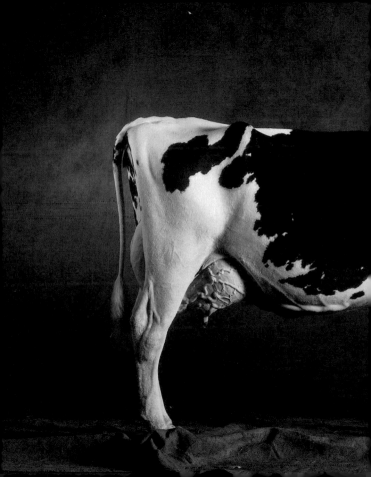

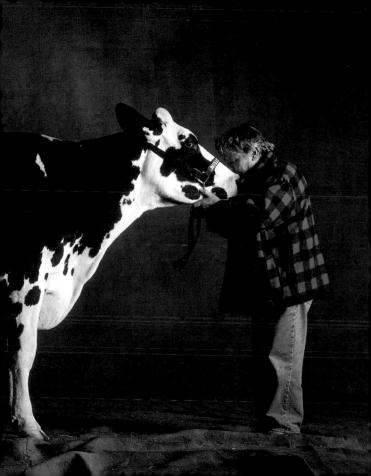

PRIM'HOLSTEIN COW

(detail of udder)

Herrico (daughter of
Besne-Buck and Flamande),
four years old; owned by
the Gadon GAEC (Commu-
nal Farming Association)
in Le Vieil Bauge, France
(*Agriculture Show, Paris*)

Overleaf:
LIMOUSIN BULL

Dimitri (son of Usant and
Taïga), seven years old,
First Prize Championship
of 1995 at the Paris Agri-
culture Show, with his
owner, Michel Camus,
breeder in Arnac La Poste,
France
(*Agriculture Show, Paris*)

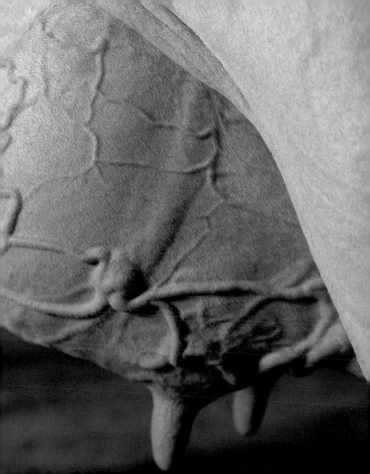

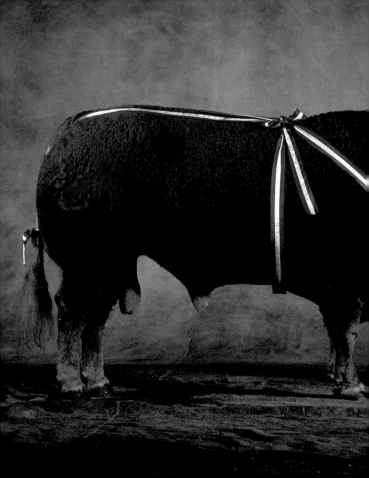

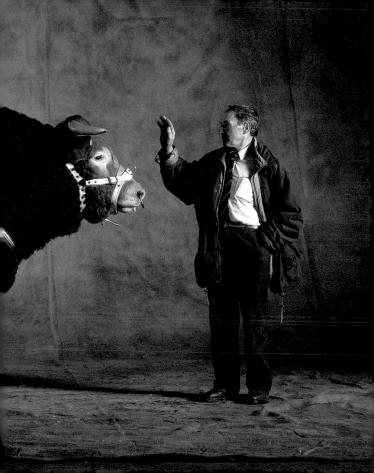

FRENCH SIMMENTAL COW
Dolly (daughter of Kanis
and Résine), ten years old;
presented by her owner,
Bernard Ramel, breeder in
Vouvray, France
(Agriculture Show, Paris)

Overleaf:
BRETON BLACK PIE COW
Écrémeuse (daughter of
Actif and Pot au Lait), nine
years old; presented by
Blandine Staskewitsch;
owned by Jacques Cochy,
breeder in Donges, France
(Agriculture Show, Paris)

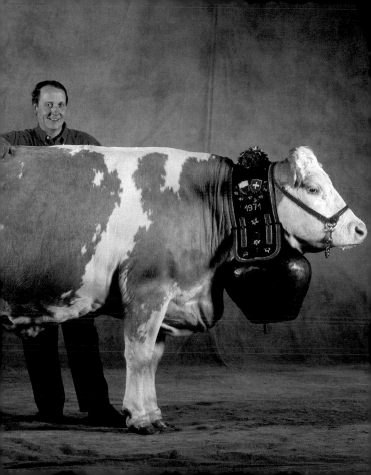

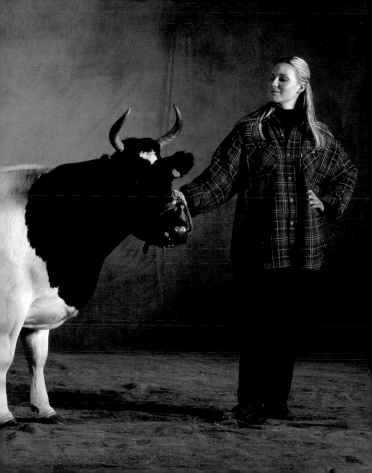

ABERDEEN-ANGUS BULL

Ellanin Camelot; presented
by his owner, Madame
Pittams, of Llanwern,
Brecon, Wales
(Royal Show, England)

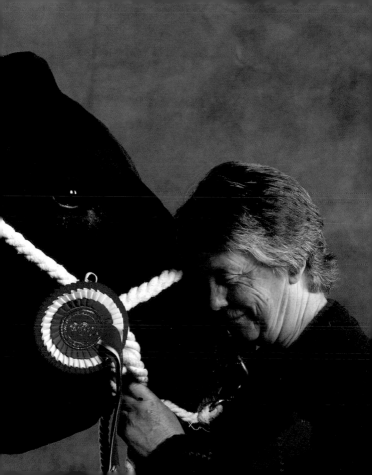

ARDENNES STALLION

Espoir des Joncs (son of Albion du Madon
and Union de l'Hospital), three years old;
presented by his owner, Pol Gonnet, breeder
in Jonville-en-Woëvre, France
(*Agriculture Show, Paris*)

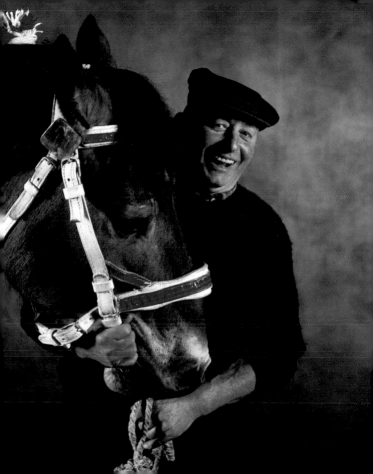

FLAMANDE COW

Vanille (daughter of
Jupiter), six years old and
weighing 1,703 pounds;
presented by Clement
Cleenewerck
(*Agriculture Show, Paris*)

Overleaf:
ANGLO-ARAB STALLION

Quain (son of Emir IV and
Maïa du Vent), of Haras
du Pin, France
(*Haras du Pin, France*)

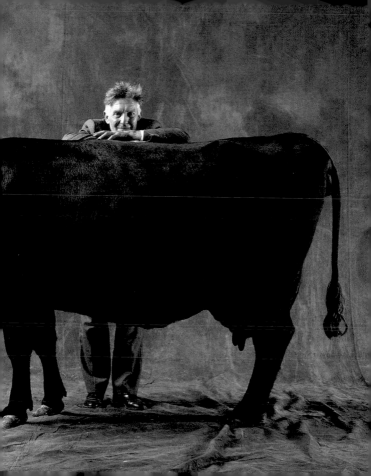

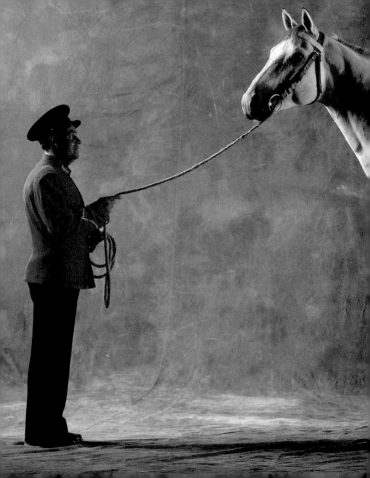

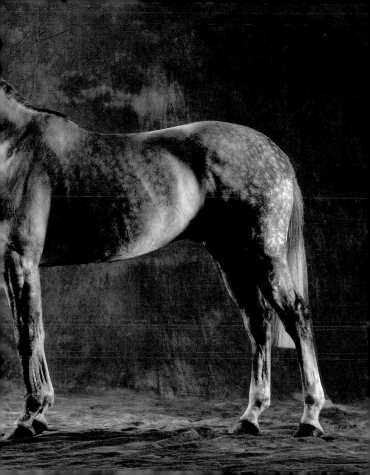

NORMAN COW

Fusée (daughter of Deslac and Brunette),
eight years old, presented by Aurore, daughter of her owner Gilbert Parrein, of Saint
Nicolas de Sommaire, France
(Agriculture Show, Paris)

Overleaf:
ARDENNES STALLION

Bonar du Moulin (son of Odéon de la
Rosières and Nénette du Moulin), three
years old; presented by his owner, Cécile
Blaise, breeder in Grimaucourt, France
(Agriculture Show, Paris)

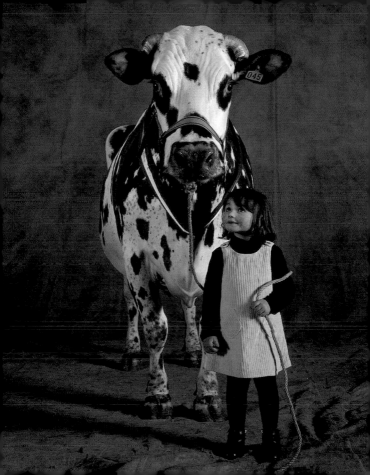

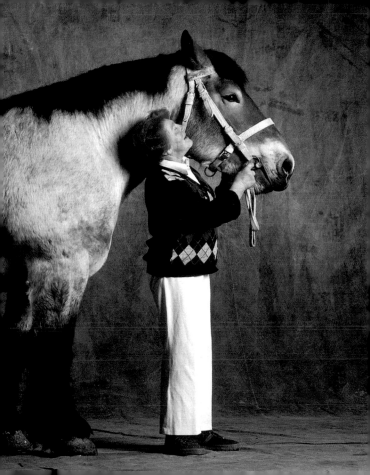

VENDÉE RAM

Presented by Jérôme Galland
(Agriculture Show, Paris)

Overleaf:
MONTBÉLIARD COW

Bergère (daughter of Nevada and
Sérénade); presented by Victor
Regnaud; owned by Jean Garnier
(Agriculture Show, Paris)

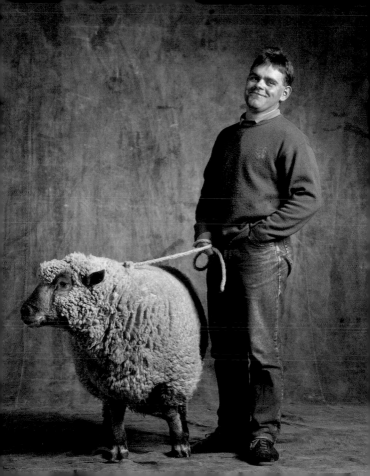

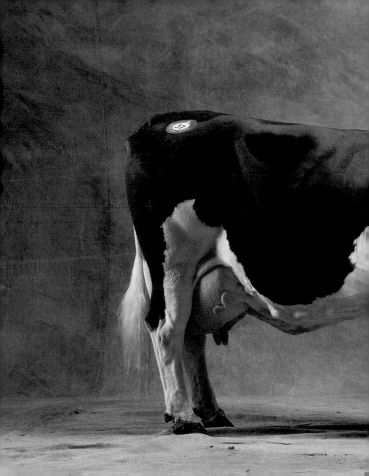

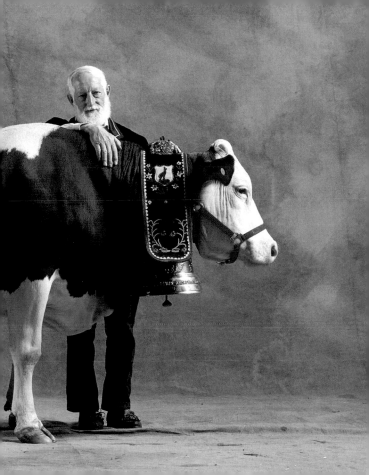

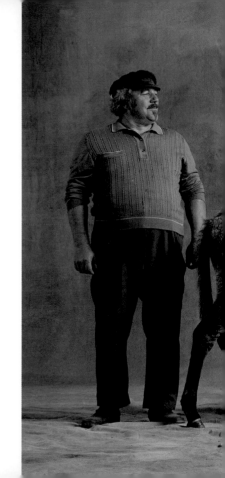

GRAY PROVENÇAL DONKEY

Gamin, with his owners, Roland and Marie Pevent
(*Lessay Fair, France*)

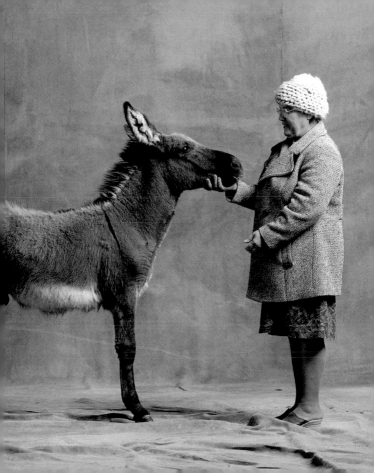

ROUSSIN EWES

Presented by Tom Merchant, breeder;
owned by Maurice Viel of Brix, France
(Agriculture Show, Paris)

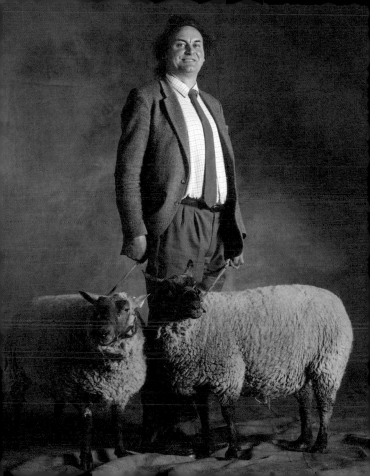

LARGE WHITE PIG

Felomena and her piglets,
presented by their owner,
Giovanni Ottorino
*(Verona Agriculture Fair,
Italy)*

Overleaf:
RETINTA COW

Mayordoma (daughter of
Ahorrativo and Carcelera);
presented by the owner's
daughter, Maria Eugenia
Raschetti, "La Salamanca"
Cabaña
(La Rural, Buenos Aires)

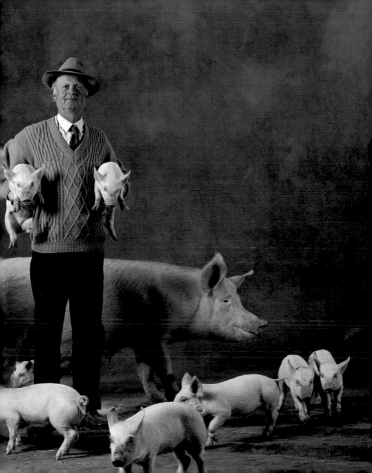

TAMWORTH PIG

Gillhouse Lucky Lass, called Lucy; presented
by Jane Hurford; owned by Viki Mills of
Crediton, Devon, England
(Royal Show, England)

Overleaf:
BOULONNAIS MARE

Rebecca (daughter of Hercule), seven years
old; presented by Mr. Degardin
(Agriculture Show, Paris)

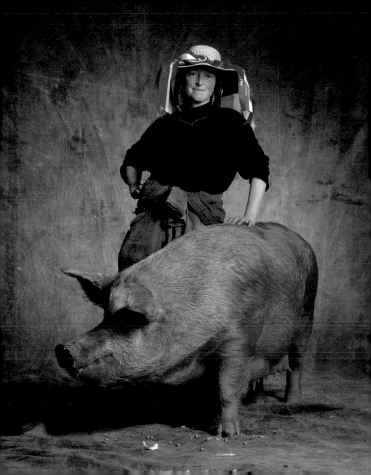

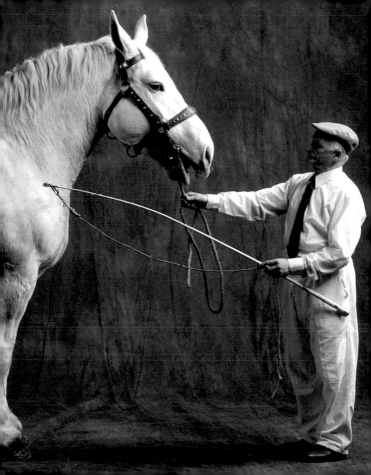

SELLE FRANÇAIS MARES

Broodmares and their
offspring; owned by Arsène
Aubry
(Lessay Fair, France)

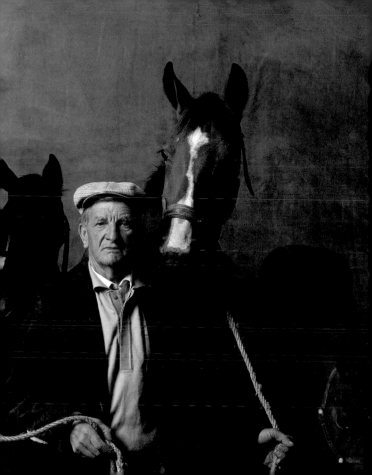

LACAUNE EWE

Eighteen months old; pre-
sented by Fernand Delmas,
breeder; owned by Eugène
Combebiac of Montvalen,
France
(Agriculture Show, Paris)

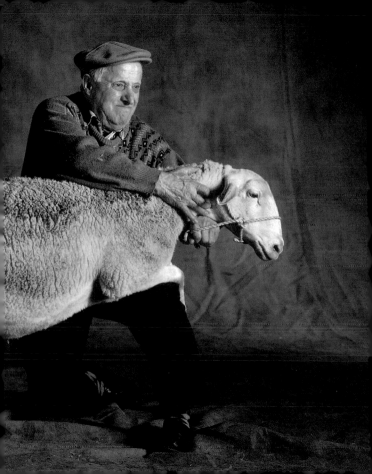

ARLES MERINO RAM

Ugolin, gelding, born in fall 1990, presented
by Flocas (leader of flock) de Magali
Lemercier, of Saint-Martin-de-Crau, France
(*Agriculture Show, Paris*)

Overleaf:
ALPINE GOATS

Females presented by Mr. and Mrs. Paul
Georgelet
(*Agriculture Show, Paris*)

LANDRACE GILT PIG

Anslet, presented by her owners, Arthur and Joan Uglow of Devon, England
(*Royal Show, England*)

Overleaf:
MIDDLE WHITE PIG

Gillhouse Fairlady V, called Little Pudding; presented by John Hurford; owned by Viki Mills, of Devon, England
(*Royal Show, England*)

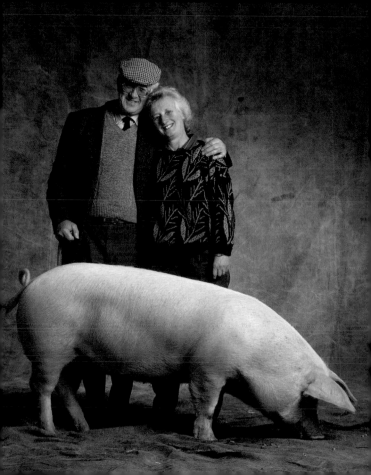

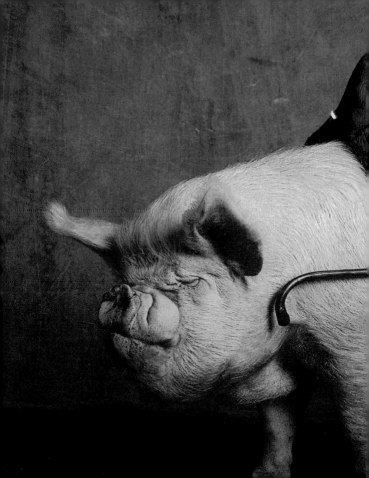

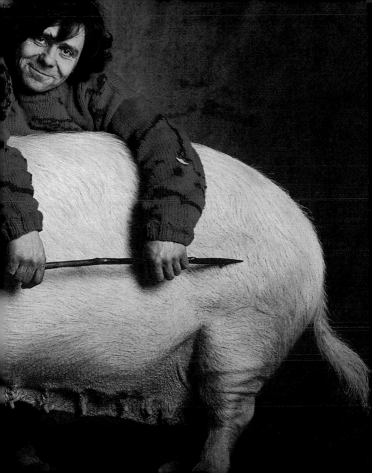

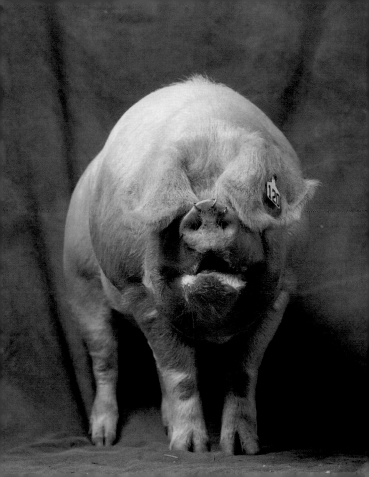

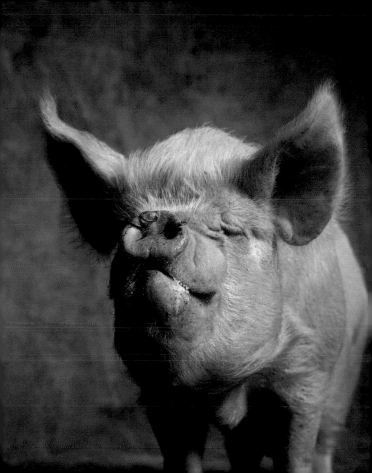

Preceding left page:

NORMAN, OR WESTERN WHITE, PIG

Dolmen de Dangy, two years old; owned
by Achille Marie
(Agriculture Show, Paris)

Preceding right page:

MIDDLE WHITE PIG

Gillhouse Fairlady V, called Little Pudding;
owned by Viki Mills, of Devon, England
(Royal Show, England)

BLUE MAINE RAM

Fortress; presented by James K. Goldie,
breeder in Dumfries, and his two sons
(Royal Show, England)

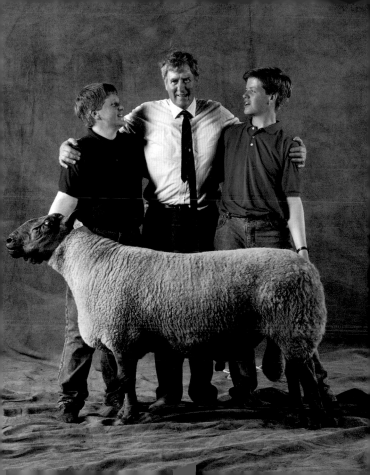

CAUSSES DU LOT EWE

Presented by Pascal Cailleau
of the Gaec de Chalvet
(Communal Farming Asso-
ciation) in Le Bastit,
France
(Agriculture Show, Paris)

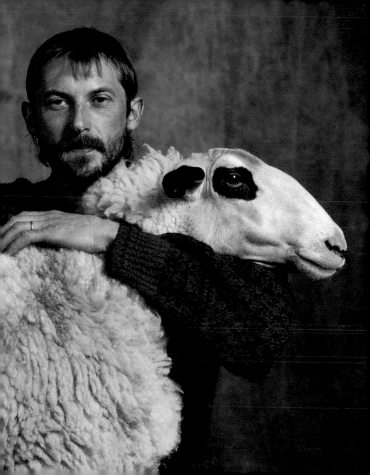

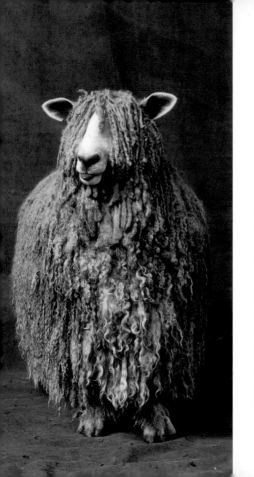

LINCOLN EWE

Greengatte Hannah;
owned by Sally Chapman
(Royal Show, England)

**CORRIEDALE-IDEAL
CROSS**

Ewe sheared by Juan
Carlos Alegre, gaucho
employed by Josefina
Meabe de Matho Garat,
Cabaña "La Estrella"
*(Solari, Corrientes
Province, Argentina)*

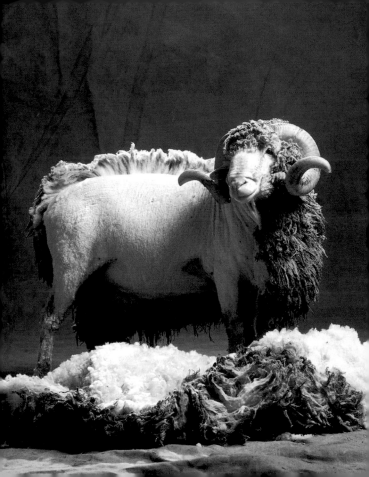

Preceding left page:

RAMBOUILLET RAM

National Sheep Farm,
Rambouillet, France
(Agriculture Show, Paris)

Preceding right page:

YOUNG GAUCHO

Juan Chamorro holding
wool from a Corriedale/
Ideal cross, Cabaña "La
Estrella"
*(Solari, Corriente Province,
Argentina)*

BERGAMASCA RAM

Three years old and weigh-
ing 321 pounds; presented
by Pietro Fiorucci; owned
by Danilo Mosconi
*(Verona Agriculture Fair,
Italy)*

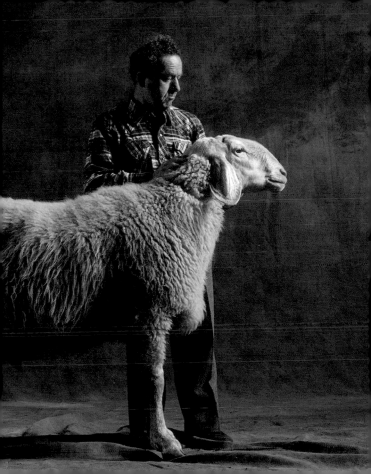

LE ROVE GOAT

Tartarin, large male, presented by Claude Servonet, breeder in Chatinais La Bergerie, France
(Agriculture Show, Paris)

150

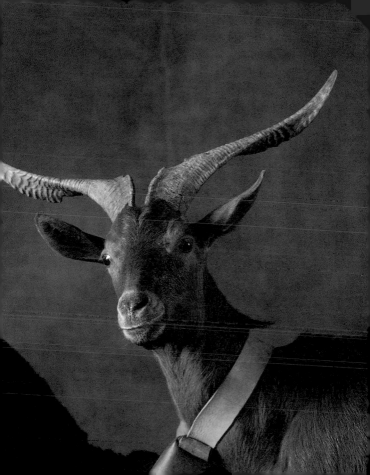

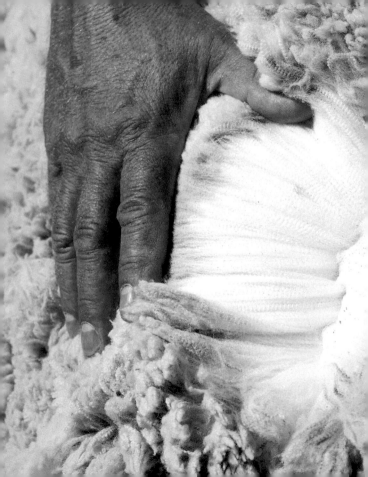

Preceding pages:

AUSTRALIAN MERINO WOOL

*(Peninsula Valdés, Province de Chubut,
Argentina)*

SOLOGNE EWE

Owned by the Vendôme Agricultural High
School in La Motte Beuvron; presented by
Alain and Nicole Pin, breeders in Pruniers,
Sologne, France
(Agriculture Show, Paris)

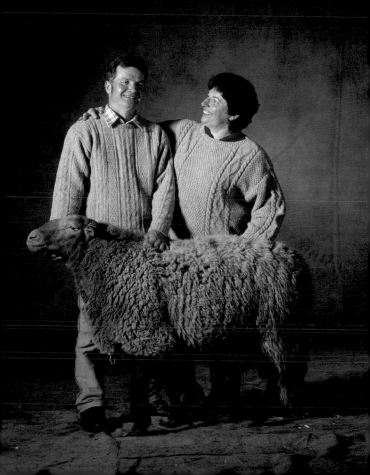

LARGE WHITE PIG

Magnifique (son of Lord and Joyeuse), three years old, with his owner Henri Petiot, of Liernolles, France (*Agriculture Show, Paris*)

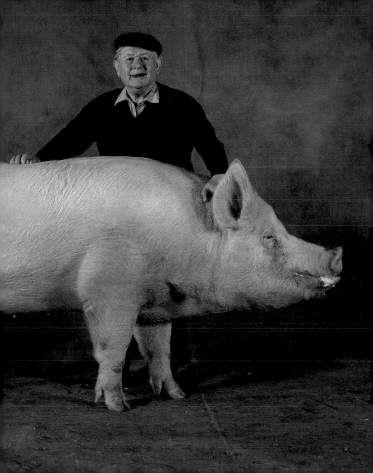

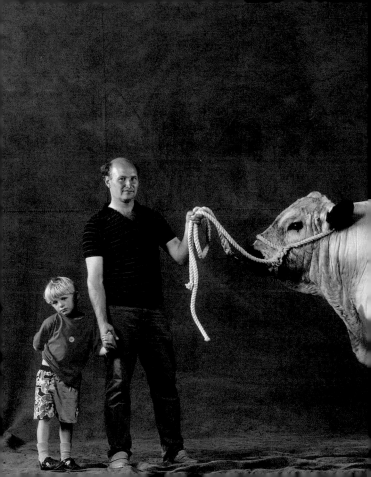

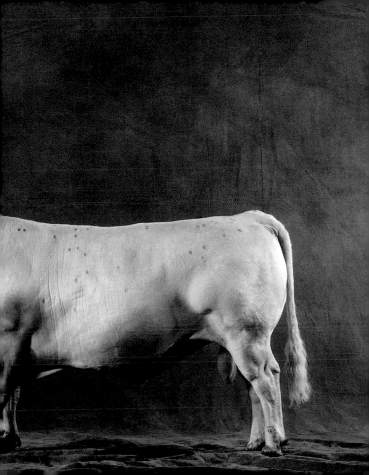

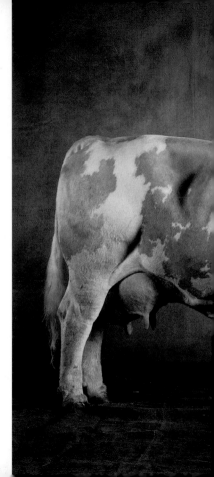

Preceding pages:
BRITISH WHITE BULL
Heving Ham Saragen, with
his owner, Mr. Sanderson,
and his son Richard
(*Royal Show, England*)

FRENCH SIMMENTAL COW
Dany (daughter of Shérif
and Thoune), six years old,
with her owner, Geneviève
Bourge, breeder in Rahon,
France
(*Agriculture Show, Paris*)

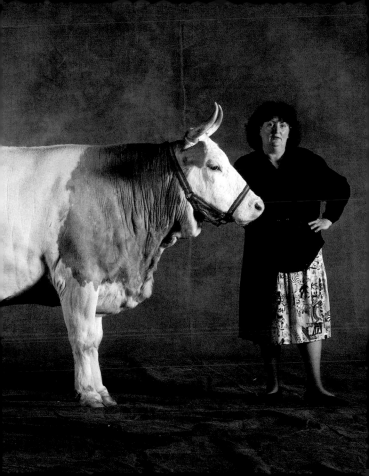

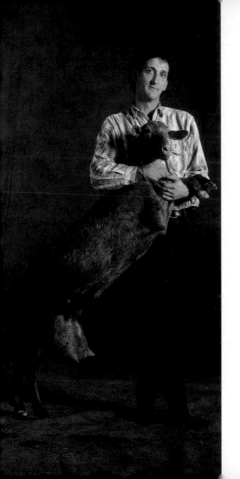

MALAGUEÑA GOAT

Female presented by Diego Leyva Ferrer; owned by the Spanish Association of Malagueña Goat Breeders
(*Agriculture Show, Paris*)

BERKSHIRE BOAR

Gillhouse Peter Lad III, called "Champion"; owned by Viki Mills of Devon, England
(*Royal Show, England*)

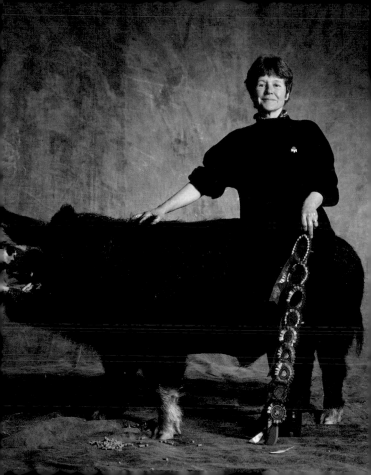

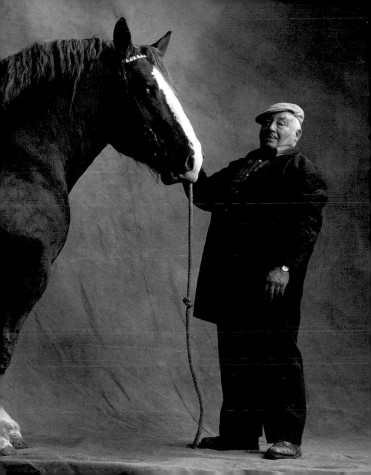

Preceding pages:

BRETON COACH STALLION

Vivaldy (son of Océanic and Marina), three years old and weighing 2,090 pounds, with his breeder, Pierre Hameury, of Plougonven, France *(Agriculture Show, Paris)*

CLUN-FOREST RAM

Tommy; owned by Mr. Francis of Guifron Farm, in Morncastle, England *(Royal Show, England)*

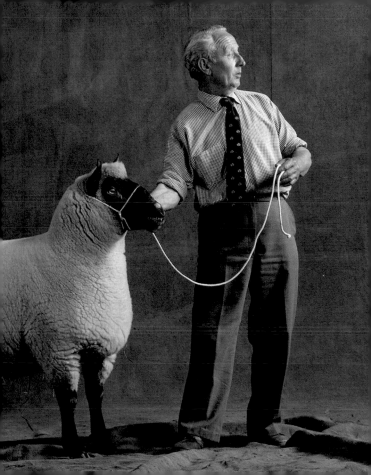

CHARMOISE EWE

Shown with her lamb and their owner,
Daniel Mougin of Castres, France
(Agriculture Show, Paris)

Overleaf:

POITEVIN MULE

Une Thalia; owned by Eric Rousseau de
Vouille in Les Marais, with André and
Marcelle Bureau, mule breeders for three
generations
(Agriculture Show, Paris)

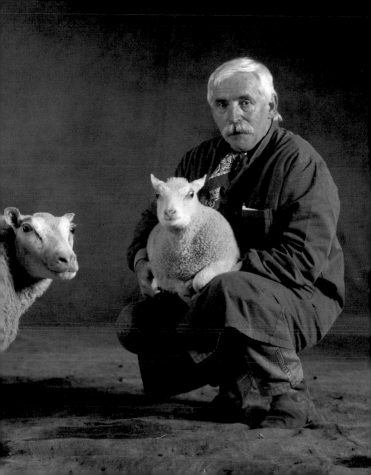

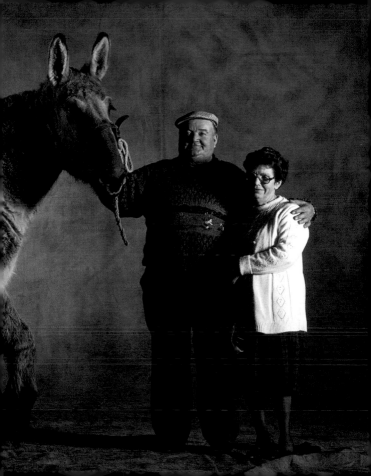

ROMANOV RAM

Presented by Didier Perreal;
owned by Montmorillon
GE.O.DE. (Ovine Genetics
and Development)
(Agriculture Show, Paris)

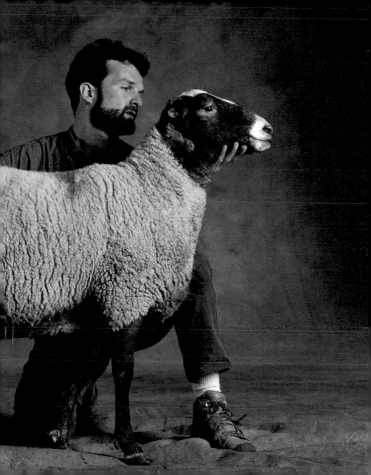

INRA 401 RAM

Presented by Didier Perreal; owned by
Montmorillon GE.O.DE. (Ovine Genetics
and Development)
(*Agriculture Show, Paris*)

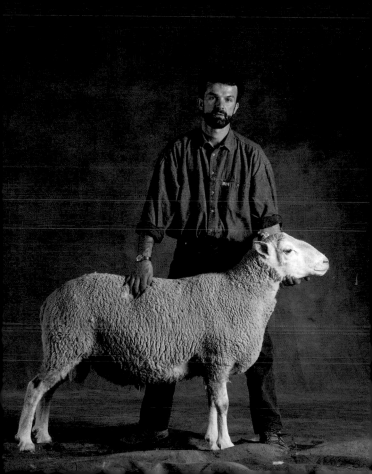

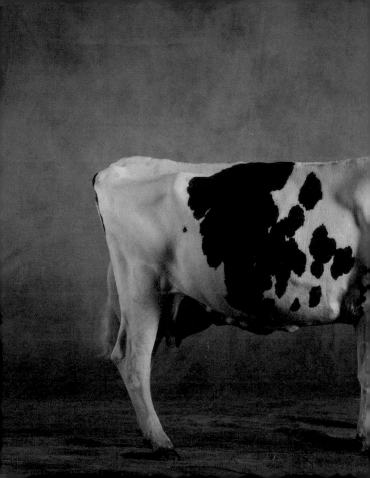

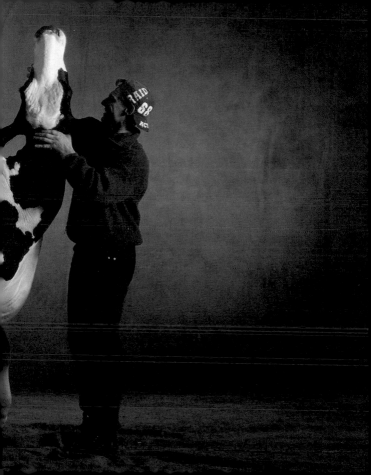

Preceding pages and opposite:

PRIM'HOLSTEIN COW

Joviale (daughter of
Holiday and Hirondelle),
four years old; owned by
Jérôme Triffault, repre-
senting the eighth genera-
tion on the Bel Oeillet
Farm in Courcemont,
France
(*Agriculture Show, Paris*)

Overleaf:

PERCHERON STALLION

Terrible (son of Iran and
Lorraine), ten years old,
with his owner, Michel
Lepoivre, of Saint Aubin
de Couteraie, France
(*Agriculture Show, Paris*)

178

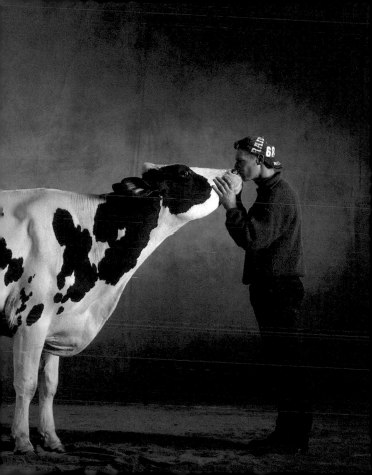

COTENTIN DONKEYS

Gladis du Bocage and her
son Joujou; owned by
Gilbert Mouchel-Vichard,
breeder in Villy-Bocage,
France
(Agriculture Show, Paris)

Overleaf:
AUXOIS MARE

Isabelle (daughter of Défit
du Chateau and Belle
Etoile), four years old,
with her owner Jean
Détain of Nuits-Saint-
Georges, France
(Agriculture Show, Paris)

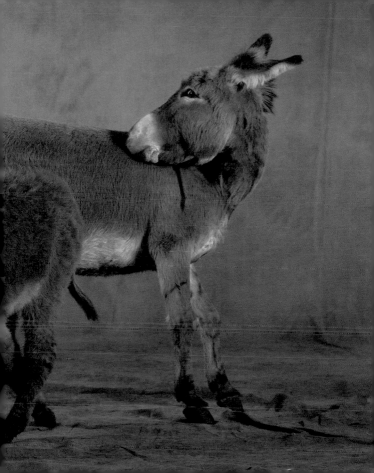

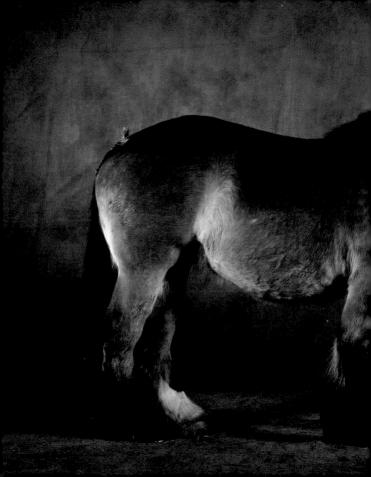

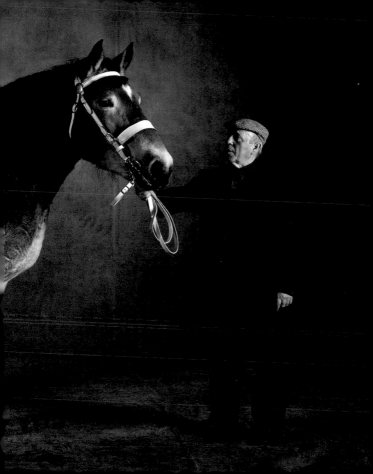

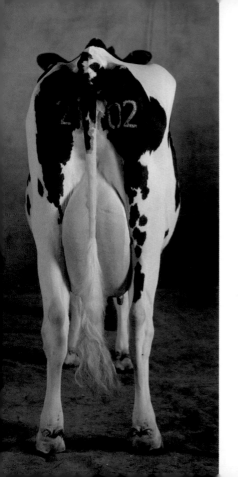

PRIM'HOLSTEIN COW

Jerrico (daughter of Besne-Buck and Flamande), four years old; owned by Gadon GAEC (Communal Farming Association), in Le Vieil Bauge, France (*Agriculture Show, Paris*)

AUBRAC BULL

Joyeux (son of Exquis and Altesse), four years old and weighing 2,695 pounds; owned by Guy Barriol, breeder in Cezens, France (*Agriculture Show, Paris*)

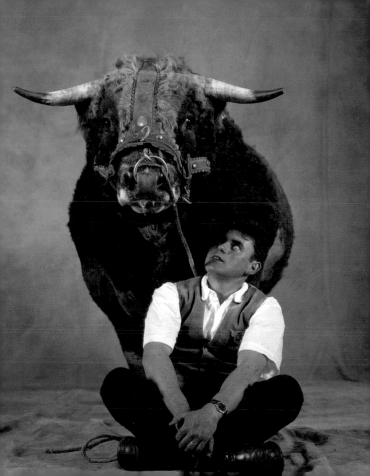

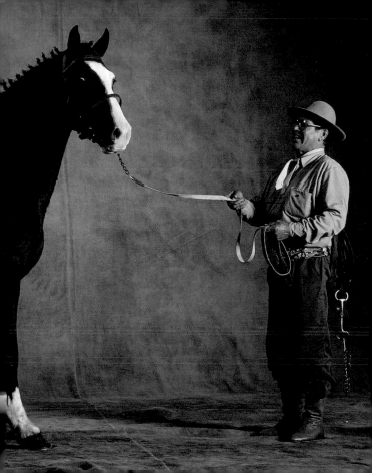

Preceding pages:

HACKNEY STALLION

Saint Peter White Face
(son of Saint Peter Master-
less and Greenmeadows
Nat); presented by Julio
C. Martinez; owned by
Enrique Debaiggi, Cabaña
"La Vanguardia"
(*La Rural, Buenos Aires*)

CHARMOISE EWE

Mother and her lambs;
owned by Brigitte Lagorce,
breeder in Champagnat,
France
(*Agriculture Show, Paris*)

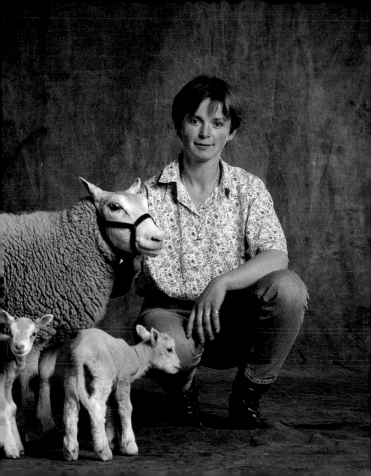

CHAROLAIS BULL

Caylers Crackerjack, the
founding sire of Baggrave
Farm, presented by Leisa
Cargill
(Royal Show, England)

Overleaf:
**PIMPERNEL
SIMMENTAL BULL**

Whitemine Vampire;
accompanied by Laura
Morris; owned by
Bernard E. Kenney of
Leicestershire, England
(Royal Show, England)

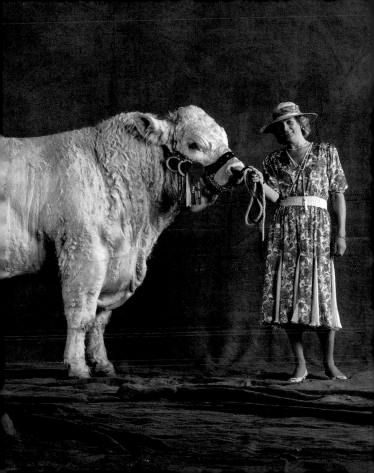

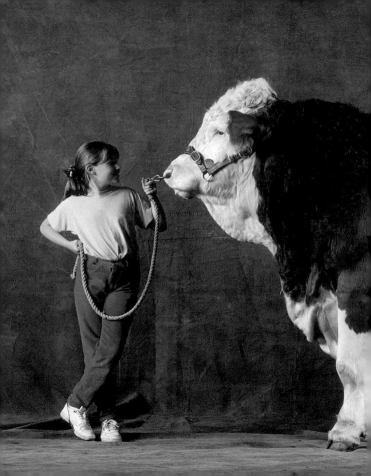

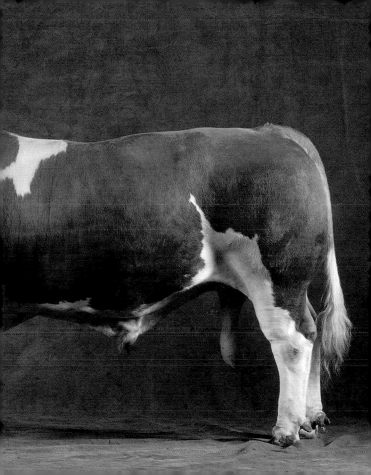

RAÏOLE EWE

Owned by the Mas de Saporta Breeders'
Association in Lattes and presented by
Sandra Boos
(Agriculture Show, Paris)

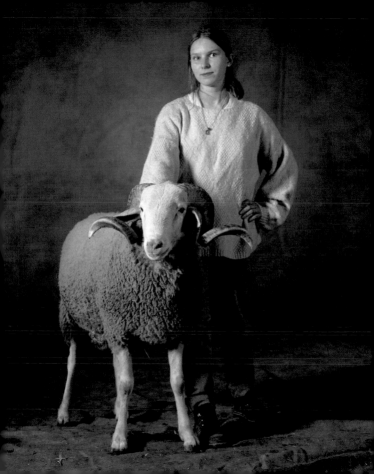

BLONDE D'AQUITAINE COW

Hilarie (daughter of
Éminence and Estonia);
presented by her owner,
Angèle Barbaz, of Coudray
au Perche, France
(*Agriculture Show, Paris*)

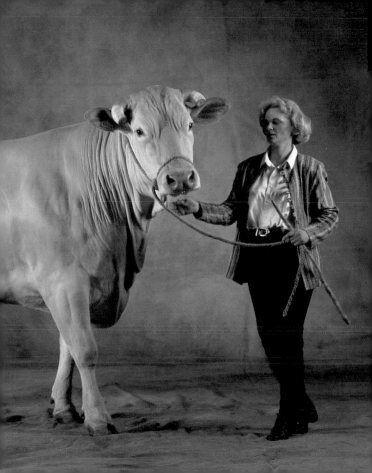

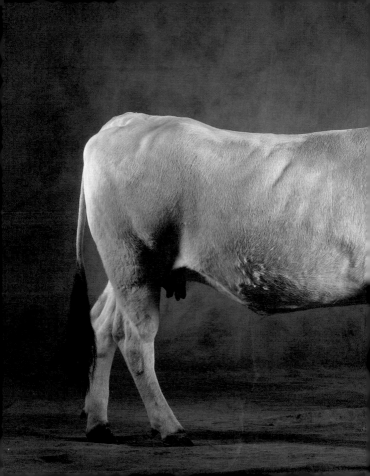

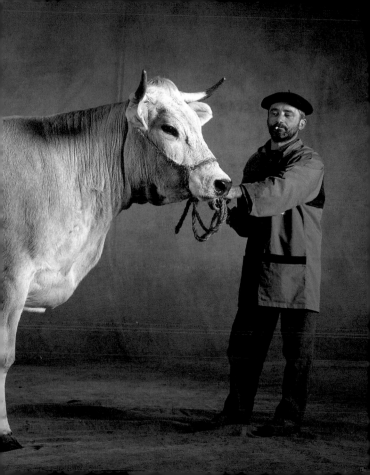

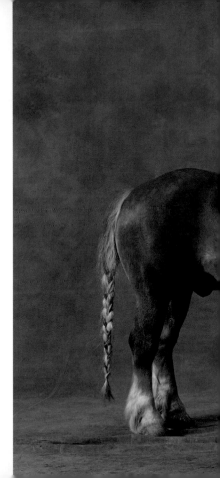

Preceding pages:

**GASCON AREOLE,
OR MIRANDAISE, COW**

Idole (daughter of
Farouche and Marquise),
five years old, with her
owner, André Blancafort
of Clermont-Pouyguilles,
France
(*Agriculture Show, Paris*)

**ITALIAN HEAVY DRAFT
HORSE**

Arco, six-year-old stallion;
presented by Davide
Spiniella; owned by Inter-
mizoo S.P.Q.
(*Verona Agriculture Fair,
Italy*)

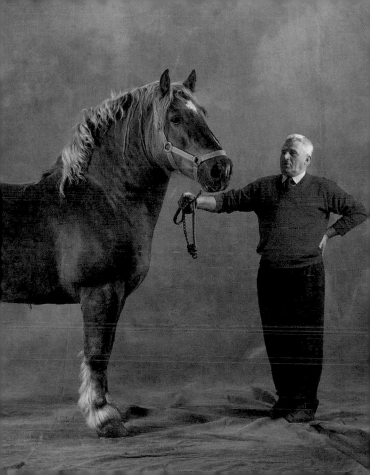

LONGHORN BULL

Plaitford Orlando, with his owner, Adrian
McConnel, of Romsey, Hants, England
(Royal Show, England)

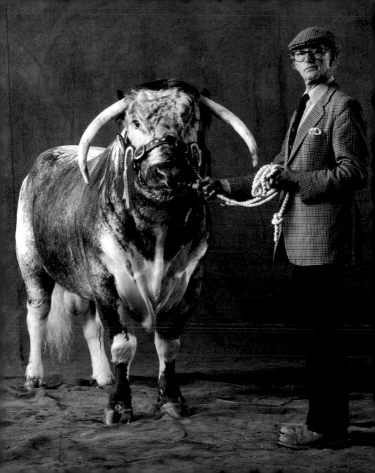

ROMAGNOLA BULL

Zago, weighing 1,782
pounds; presented by
Bruno Tossani; owned by
the Tossani brothers
(*Verona Agriculture Fair,
Italy*)

Overleaf:
PORTLAND RAM

Harper of Tetford, accom-
panied by J. Richard
Harper-Smith of
Lincolnshire, England
(*Royal Show, England*)

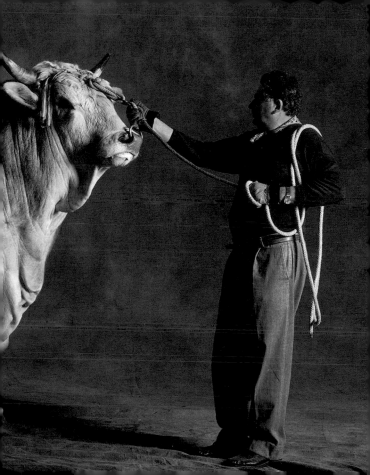

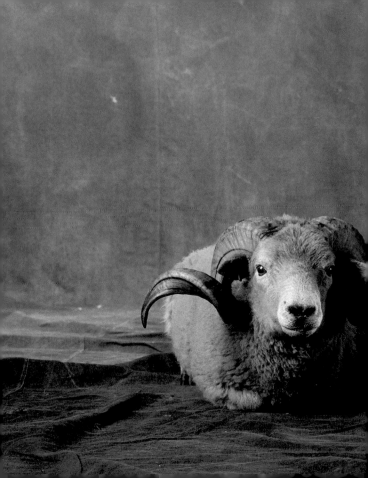

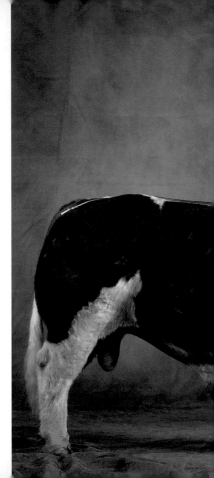

MAINE-ANJOU BULL

Filou (son of Lascar and Danseuse), eight years old, 1998 Paris Agriculture Show Champion, with his breeder, Thierry Bournault, of Chanteray Villedieu, France
(*Agriculture Show, Paris*)

Overleaf:
MAINE-ANJOU BULL

Jardin (son of Bison and Gerboise), four years old, with his breeder, Hervé Daillère, of Seiches-sur-Loire, France
(*Agriculture Show, Paris*)

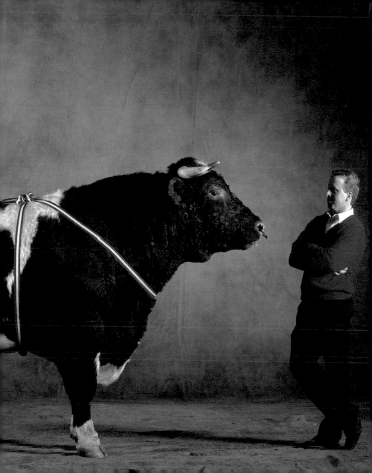

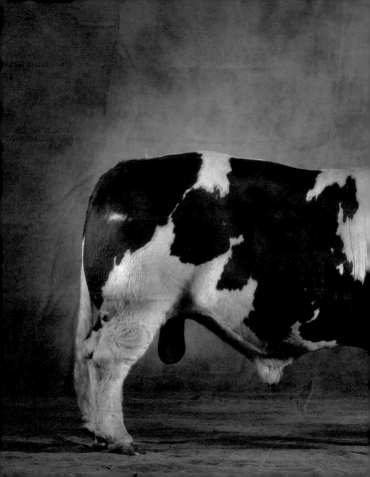

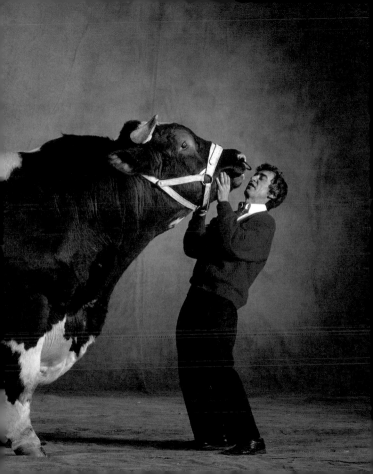

PIRENIACA COW

Malvina; presented by
Barazabal-Origoyen;
owned by Indart Frères,
Spain
(*Agriculture Show, Paris*)

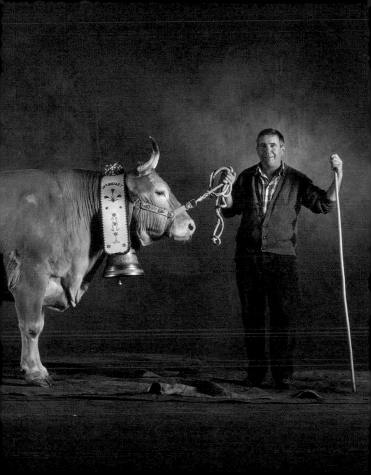

AUBRAC COW

Vipère (daughter of Princou and Ruzade), and her calf; owned by Jean-François Petit of Aurelle-Verlac, France
(Agriculture Show, Paris)

Overleaf:
CHAROLAIS BULL

Jupiter (son of Érudit and Colombe), four years old, with his owner, Jean-Guy Vannier, of Valette-La Chapelle in Le Mans, France
(Agriculture Show, Paris)

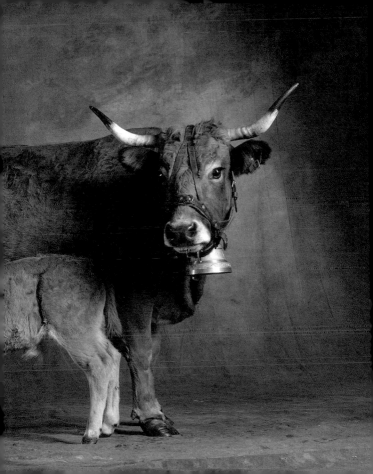

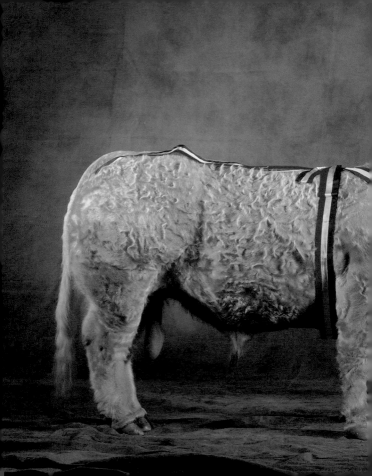

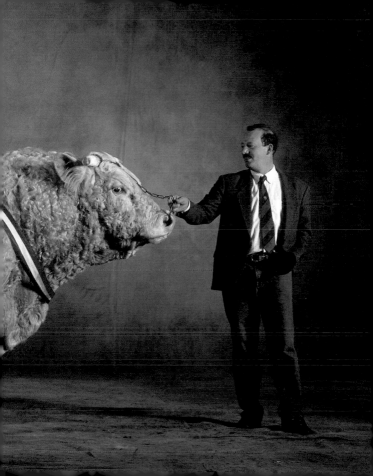

MARAÎCHINE COW

Nini (daughter of Jojo and
Bercère), at twenty-one
years old the oldest bovine
at the 1998 Agriculture
Show; accompanied by
Bernard Arthus; owned by
the Arexcpo Association,
in Daviaud
(*Agriculture Show, Paris*)

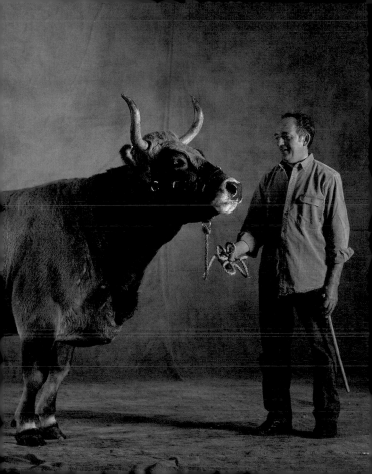

CHIANINA BULL

Frano, four years old and weighing
3,102 pounds; accompanied by his owner,
Pietro Fiorucci
(Verona Agriculture Fair, Italy)

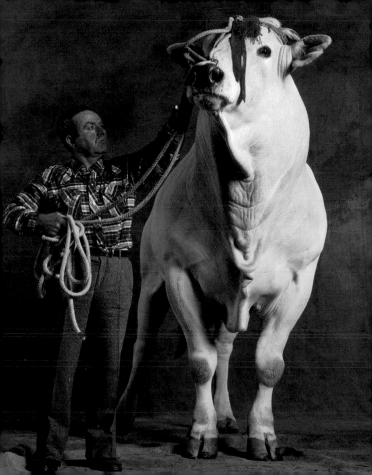

MARCHIGIANA BULL

Dorico, five years old and
weighing 3,014 pounds;
presented by Ernesto
Menghi and Tom; owned
by the Macerata Artificial
Insemination Center
(*Agriculture Show, Paris*)

Overleaf:
MARCHIGIANA BULL

Mirino, weighing 2,706
pounds; accompanied by
Ernesto Menghi; owned
by the Associazione
Provenciale Allevatori
Centro Tori di Macerata
(*Verona Agriculture Show,
Italy*)

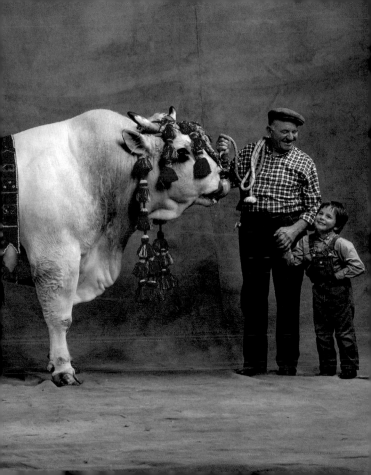

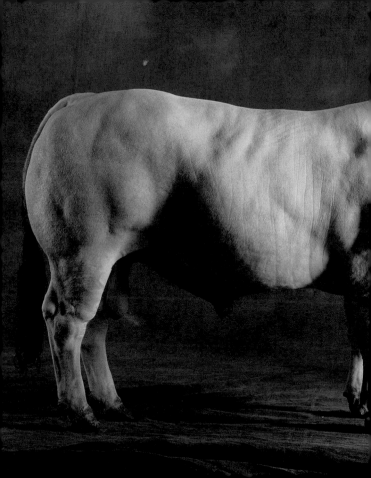

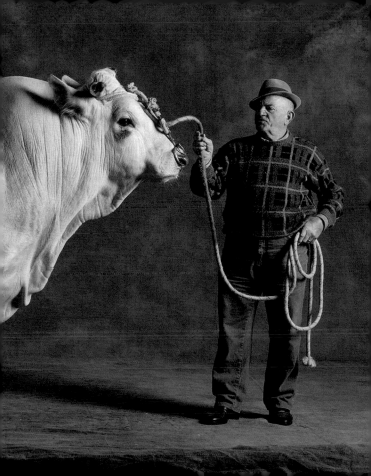

BAZADAIS BULL

Iccbcrg (son of Fabuleux and Batna), five years old and weighing 2,473 pounds; accompanied by Philippe Grelaud; owned by the Centre d'Aide par le Travail Agricole of Captieux, France
(Agriculture Show, Paris)

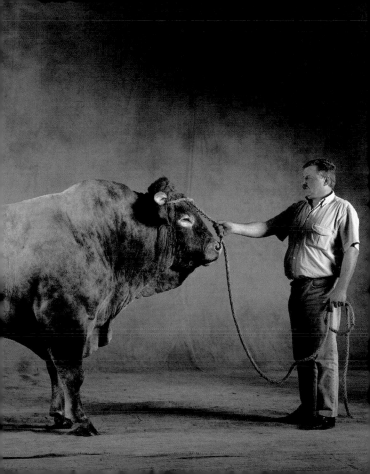

LIMOUSIN BULL

Joyau, four years old and
weighing 2,970 pounds;
accompanied by his owner,
Daniel Peyrot, of Vallière,
France
(Agriculture Show, Paris)

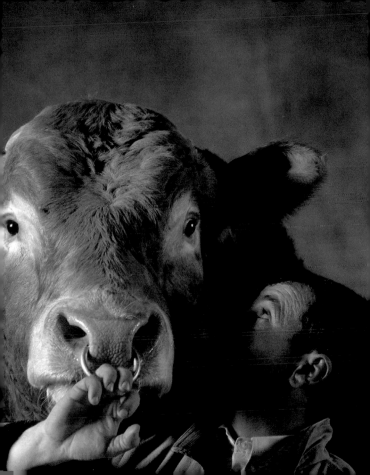

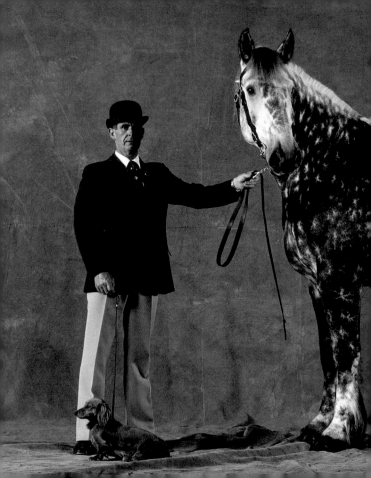

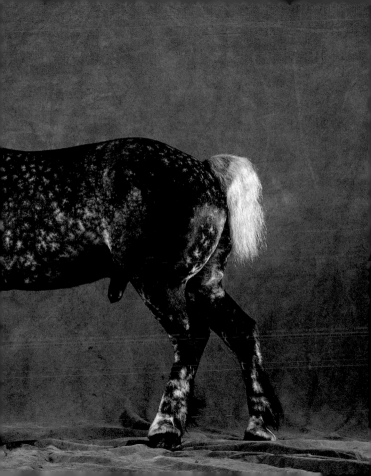

Preceding pages:
PERCHERON STALLION
Sam, presented by J. E.
Young, of Corringham,
Essex, England
(Royal Show, England)

ARGENTINE HOLANDO COW
Nogales Vanguard Marys
Rich, three years old;
accompanied by Pedro and
Nelly Panessi; and owned
by Guido Di Tella, Cabaña
"Los Nogales"
(La Rural, Buenos Aires)

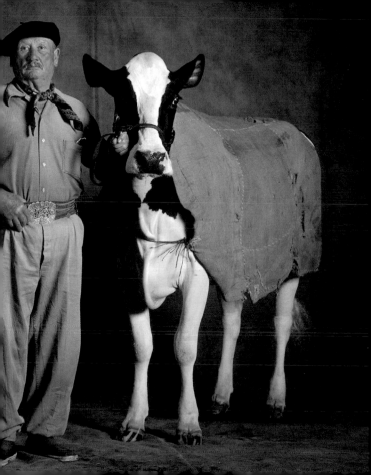

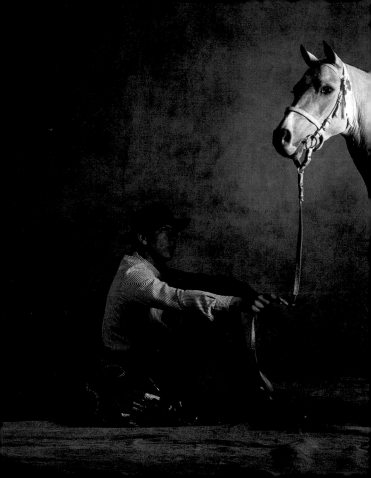

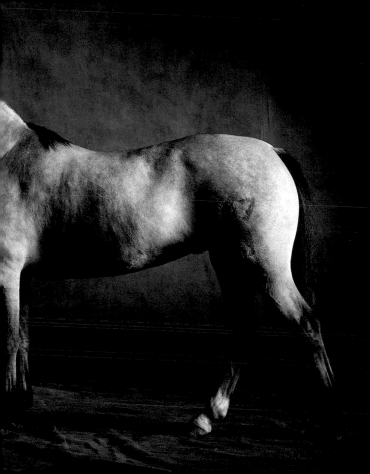

Preceding pages:

ARGENTINE PETISO PONY MARE

Bragadense Celosa
(daughter of Labra Careta
and Bettina); presented
by Daniel Meaca; owned
by Ernesto J. Figueras
(La Rural, Buenos Aires)

ARGENTINE POLO PONY

Ombucito Impacto (son
of Infidente and Loca),
three years old; presented
by Hilario Ulloa; owned
by Mrs. Orozco Echeverz,
Cabaña "El Ombucito"
(La Rural, Buenos Aires)

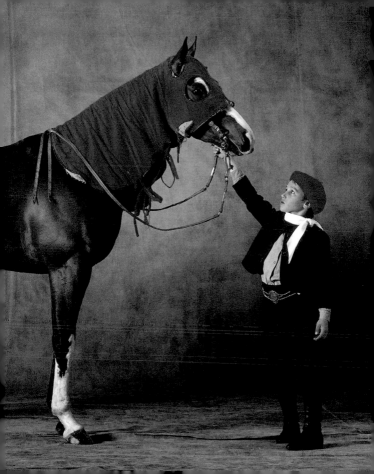

PIEDMONT BULL

Marescalla Massimo (son
of Bertu and Farfalla), two
years old; presented by
Sergio Acevedo; owned
by Cabaña "La Marescalla"
(*La Rural, Buenos Aires*)

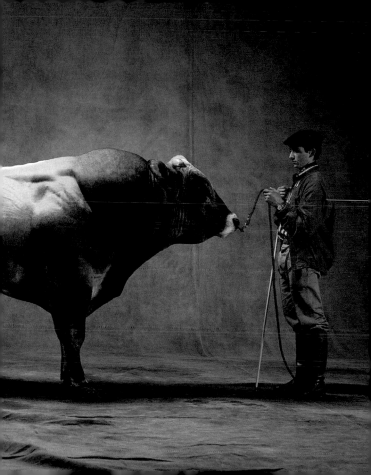

COTENTIN DONKEY

Grafton, called Colette, presented by his
owner, Rosemary A. Cameron
(Royal Show, England)

Overleaf:
BLONDE D'AQUITAINE BULL

Jocko (son of Gadichon and Eclipse),
five years old, owned by Gilles Ducom de
Fargues and presented by Anaïs Robin,
age four
(Agriculture Show, Paris)

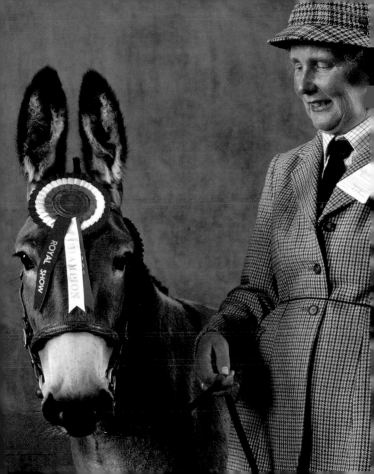

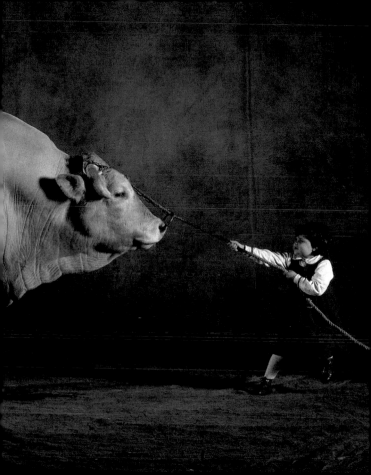

RUBIA GALLEGA BULL

Rubio, weighing 2,420 pounds;
presented by Guillermo Nuñez Castro
(Agriculture Show, Paris)

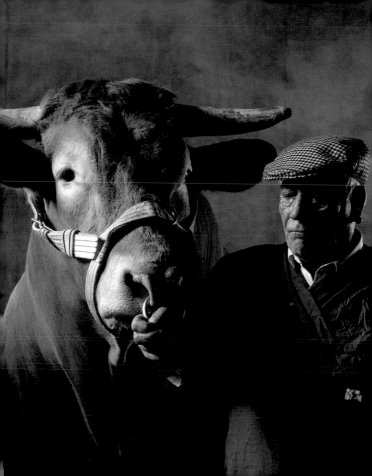

TARENTAISE COW

Hiver (daughter of Écusson and Danseuse), six years old, with her owner, Jean-Marc Veilex, of Villard Dessous, France *(Agriculture Show, Paris)*

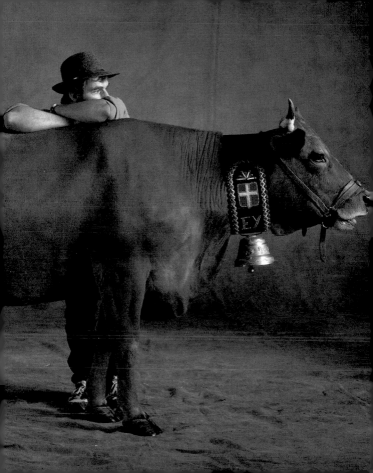

JERSEY DUROC BOAR

Marilauce 1244 (son of Marilauce and
Mardebo), weighing 605 pounds; accompa-
nied by Leonardo Ignacio Severo, son of the
owner, Leonardo Severo
(La Rural, Buenos Aires)

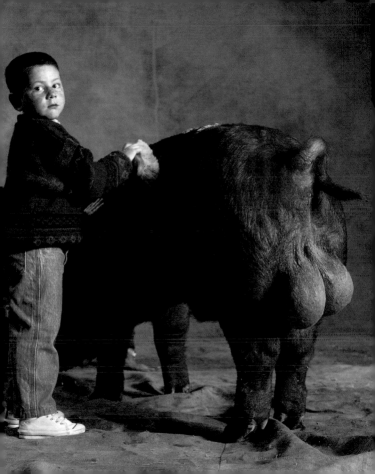

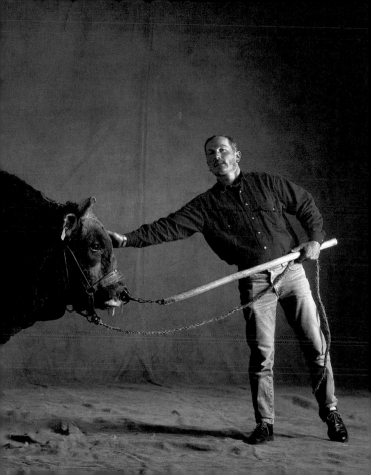

Preceding pages:

PARTHENAIS BULL

Jaguar (son of Grimpeur and Capsule), four years old; presented by his owner, Joël Maillet, of Moutiers les Mauxfaits, France
(Agriculture Show, Paris)

JERSEY COW

Marcha 48 Caucau, four years old; presented by Oscar J. Lopez; owned by Martha Socas de Videla, Cabaña 67A "Marcha"
(La Rural, Buenos Aires)

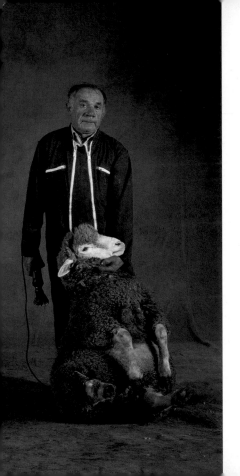

These pages and overleaf:
**RAMBOUILLET RAM
AND RAMBOUILLET EWE**

Sheared by André Mathieu,
a shepherd for thirty-three
years at the National
Sheep Farm, Rambouillet,
France
(Agriculture Show, Paris)

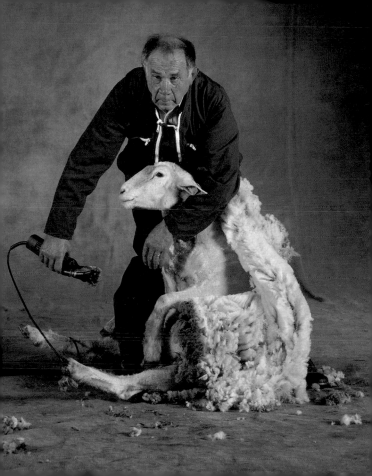

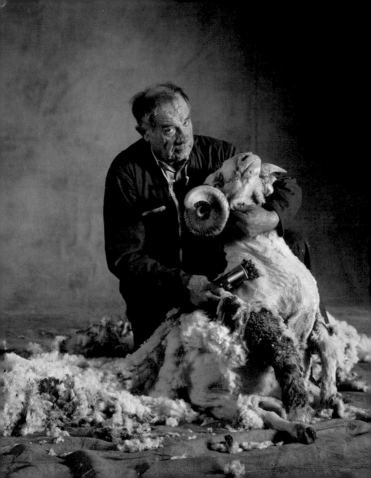

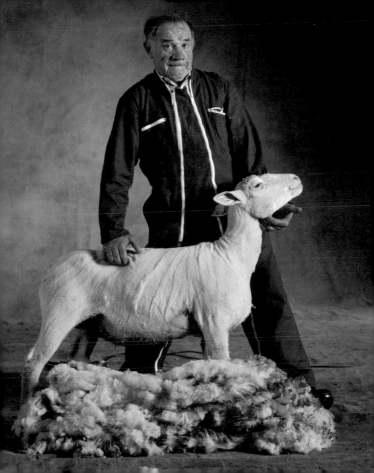

ARGENTINE PETISO PONY

Martin Fierro Mancha
(son of Charina Pacaflor
and Brava Lenteja), three
years old; presented by
Ferdinand Schultz; owned
by Anna Renata Hahn
Schultz, Cabaña "Los Tres
Petisos"
(La Rural, Buenos Aires)

BRETON DRAFT MARE

Idole (daughter of Copi
and Amonie), three years
old, owned by François Le
Cam, of Maul-Pestidient,
and presented by his
nephew Bernard Le Cam
(*Agriculture Show, Paris*)

Overleaf:
MONTBÉLIARD COW

Hiade (daughter of Urtica
and Diade), four years old;
presented by Patrick Chap-
paz; owned by Jean-Pierre
Dutang of Civrieux, France
(*Agriculture Show, Paris*)

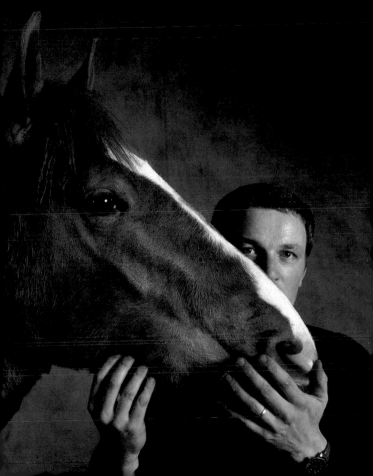

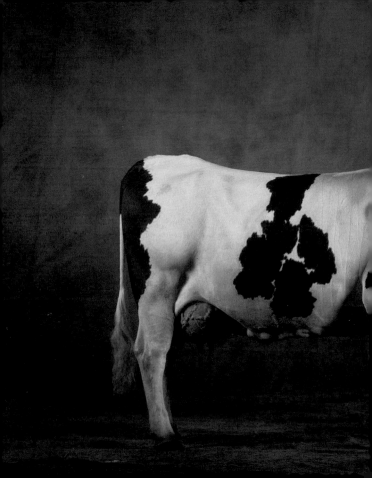

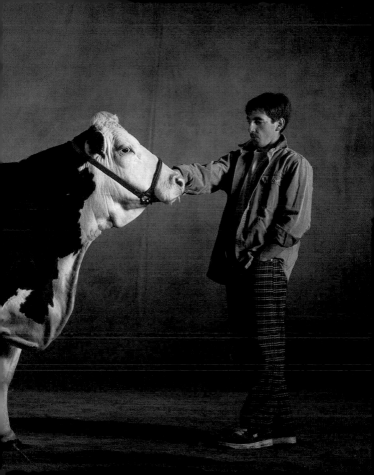

THÔNES AND MARTHOD RAM

Presented by his owner, Jean-Pierre
Chevillard, of La Vallettaz, France
(Agriculture Show, Paris)

Overleaf:
BLONDE D'AQUITAINE BULL

Eldiego (son of Clovis and Nadia),
five years old, with his breeder, Urbin
Sarcou d'Orègue
(Agriculture Show, Paris)

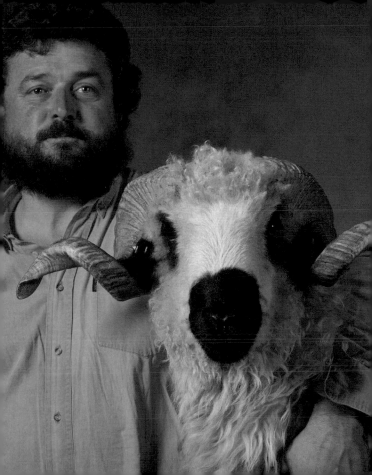

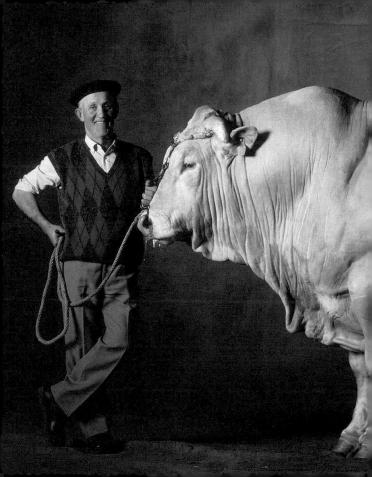

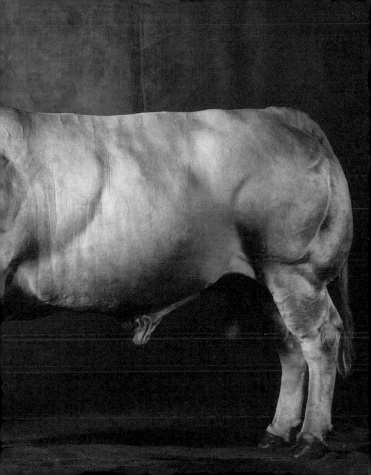

PYRENEES MULE

Doly de Cadéac; presented
by Olivier Courthiade;
owned by the Nescus Mule
School
(Agriculture Show, Paris)

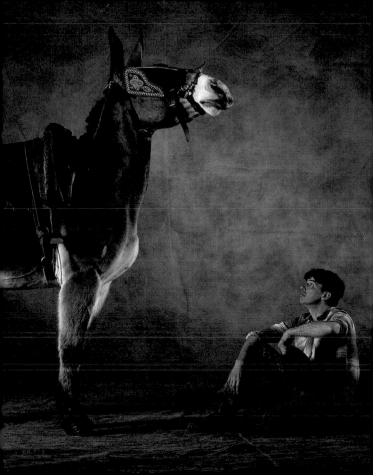

SOUTHDOWN RAM

One-year-old ram; presented by Octave
Favre; owned by Robert Durin, of Hyds,
France
(Agriculture Show, Paris)

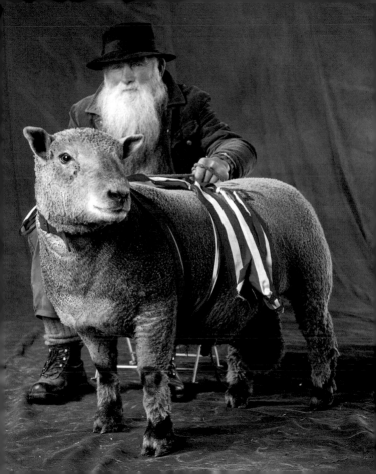

CRIOLLO HORSE

Bonito, four years old; presented by Angel Gonzalez, his wife, and their two children, in Lomas del Mirador, Argentina
(*La Rural, Buenos Aires*)

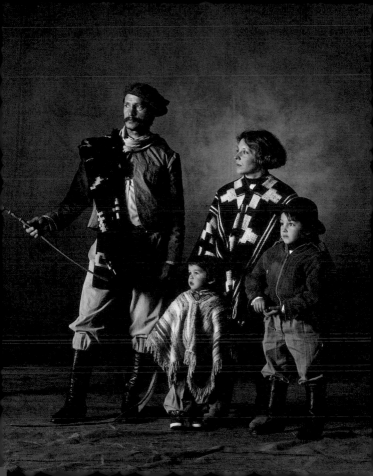

LIMOUSIN BULL

Fripon (son of Brutus and Sédentaire), four years old, with his owner, René Guinontheil of Falies, France
(Agriculture Show, Paris)

Overleaf:
BELGIAN BLUE BULL

Platinum George, owned by Canvin International Ltd., Bedford, England
(Royal Show, England)

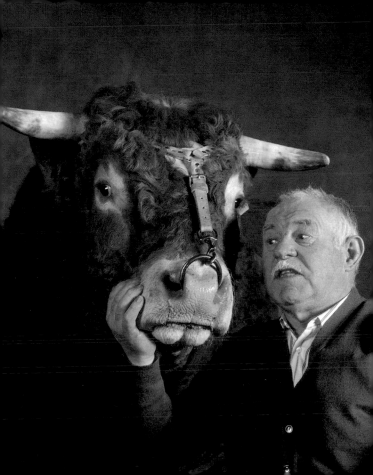

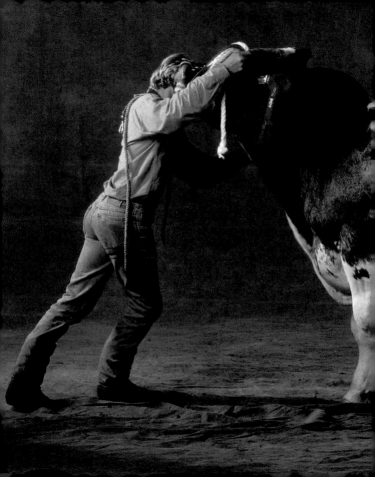

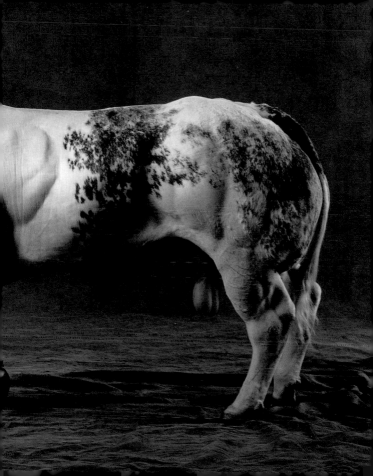

Good Breeding

Essay by Claude Michelet

Now that we have admired the magnificent animals in Yann
Arthus-Bertrand's extraordinary photographs, let us pay tribute
to their breeders, the men and women whose painstaking work
over the generations has helped to produce these creatures of
almost ideal beauty. (I say "almost" because they can still be
improved, a point on which I shall elaborate later in this essay.)
Selective breeding began over ten thousand years ago, when our
ancestors were gradually adopting a pastoral way of life. Perhaps
they were inspired by the artists who depicted wild animals in cave
paintings and clay figurines, a form in which the creatures could
be touched, caressed, and admired. Why not attempt to tame the
least fierce of the living species and then try to raise them for
specific purposes?

Prehistoric peoples had already succeeded in domesticating
dogs, which had lived near their dwellings as hunting compan-
ions for thousands of years. It was a logical next step to capture,
keep, and then breed wild species of sheep and goats for various
other uses. Over the millennia, our ancestors eventually came to
perfect certain animal types, of which the most beautiful speci-
mens are offered in these pages.

But let us make no mistake: selection alone, whether nat-
ural or contrived by humans, could never have transformed an

aurochs into a Durham, a Limousin, or an Angus bull. Likewise, breeders have not sat still with their arms crossed, patiently waiting for ordinary wild horses to turn themselves into robust Percherons, elegant Arabians, or swift Thoroughbreds.

It was by applying a keen sense of observation, an invaluable attribute in animal breeders, that prehistoric herdsmen initiated deliberate animal selection. Picking out the soundest animals, those best adapted to the climate, the terrain, and the work expected of them—such as producing meat, milk, or wool—they took the first steps in a long, slow process that would culminate thousands of years later in the wonderful animals shown here.

It was mostly instinct and the observation of animals that guided early scientists such as Pliny the Elder, who was called "the Naturalist"; Columella, the first-century Latin writer on agronomy; the French scientists Charles Estienne and Jean Liebault; the great seventeenth-century agronomist Olivier de Serres; and the English agronomists Jethro Tull, Robert Bakewell, and Charles Colling. Depending on the means at their disposal, these early researchers and many others contributed in their own way to a marked improvement of domesticated animal species.

It was not until the eighteenth century, however, that the concept of genealogy began to develop and to become more precisely defined. Although not in general use, the notion of keeping track of breeding stock had been exploited by the Arabs for centuries. Excellent horse breeders, the ancient Arabs were the first to inscribe the names and descriptions of their stallions and mares on tablets called *hudjés*. By recording the ancestry of their favorite

mounts and fastest runners, Arab breeders were able to cross-breed the descendants of these horses to produce progeny with the same traits.

But it was in eighteenth-century England that breeders actually implemented the system that would become an important step forward in the improvement of animal breeds. As an important breeder of Durham cattle once put it: "A good animal is a good animal, whatever its ancestry; but only genealogy enables us to ensure that its descendants inherit the animal's desirable qualities." By the early nineteenth century, English breeders had established studbooks, flock books, and herd books for horses, sheep and goats, cattle and pigs. Officially accepted in France about 1850, these books amounted to a kind of *Social Register* or *Who's Who* of the animal world and became standard reference works for breeders. Strict criteria were established for registering individual animals in the books so that breeders could create animals of consistent high quality with full knowledge of their ancestry. It goes without saying that the criteria for registration are equally severe today, which accounts for the justifiable pride that breeders take in having their livestock judged worthy of this veritable zoological aristocracy!

However, genealogy alone, important as it is, could not have promoted the formidable evolution of animal species within the space of a century, as evidenced by the breeds we know today. If we compare the images in this book with the engravings and photographs made of prize-winning livestock in the early 1900s, the difference between those animals and their descendants is

striking. Although the earlier animals indeed seem well-built, healthy, and beautiful, they fall far short of the shape, size, weight, performance, traits, and surely even the disposition of the animals we see in Yann Arthus-Bertrand's pictures.

Such unprecedented progress would be inexplicable were it not for the essential role played by the laws of heredity and their application and development in all breeding practices. Published by Gregor Mendel in 1866 but hardly recognized at the time, the laws of heredity were eventually accepted and developed in the early 1900s by such scientists as Hugo de Vries in Holland, Erich Tchermack von Seysenegg in Austria, and Carl Erich Correns in Germany. It was at that time that genetics began to attain the important place in animal husbandry that it has occupied ever since. This specialized branch of science enabled breeders to understand, and in some cases to control, the role of dominant and recessive genes, along with that of consanguinity, with its advantages and disadvantages. Genetics also made it possible for researchers and breeders to carry out extensive experimentation in crossbreeding and hybridization, thus contributing to the development of new breeds. At the same time, technical progress was made by agronomists: new methods were applied to farming and fertilization; new plant types were created; and dramatic progress was made in veterinary science. As a result, breeds of all kinds of livestock—in developed countries at least—evolved in the direction of the beautiful examples shown in these pages. By midcentury it seemed that perfection was at hand, but the art of breeding had yet to be revolutionized by a technique that became

widespread after World War II: artificial insemination.

Legend has it that artificial insemination was developed in the fourteenth century, when the Arabs, ever striving to improve their horses, first experimented with this new technique. The results of such an attempt, if it actually occurred, are not known, since no records have survived. In 1780 the Italian biologist Lazzaro Spallanzani demonstrated the possibility of using artificial insemination in dogs, but the technique was not taken seriously or perfected until many decades later, notably by the Russian biologist Ilya Ivanov about 1907. The technique of freezing semen for storage was perfected in the 1940s, and innovations continue to be made.

Today, artificial insemination has been practiced for more than fifty years on virtually all domesticated species—even honey bees—and it has not only transformed but also improved the conformation and productivity of livestock. Moreover, while a bull or a stallion in the past could mate with only a limited number of cows or mares, today's techniques of diluting, storing, and distributing semen make it possible for the same animal to impregnate thousands. Better still, if his progeny comes up to expectations, a sire can continue to participate long after his death in the production of heirs with his same qualities. It is even possible, thanks to the development of embryo-transfer techniques, for multiple eggs of a particularly prized female to be gathered, fertilized, frozen, and transferred to other females for gestation and birth, extending her own genetic traits far beyond her single annual offspring.

Of course, not all breeders practice artificial insemination on their livestock. The Thoroughbred, for example, is one of the few breeds of horses in which the use of artificial insemination is strictly limited. And, as the photographs in these pages demonstrate, some breeders prefer to breed and raise their own sires rather than rely on semen from outside stock. As a rancher myself for more than twenty-five years, I share their feelings, for I too have experienced the joy and pride that come with rearing a widely admired progenitor and the pleasure that derives from being able to control the evolution of one's own herd. That being said, there is no doubt that artificial insemination, as it is practiced around the world, will continue to improve almost all the great animal species bred by man.

This brings us to the chasm that separates serious breeders from the biologists who specialize in artificial reproduction. At the risk of shocking genetic engineers, clone conceivers, and other sorcerers' apprentices, I would like to state here categorically that the future of livestock breeding is definitely not in their hands. Whatever talent and expertise they may enjoy, these scientists will never merit the noble title of breeder. At best, they may become manufacturers of living copies, but the progeny that emerge from their test tubes—however successfully they may have been engineered—can never compare with the splendid animals in these photographs. I cannot stress enough my conviction that the animals presented in *Good Breeding* are the result of the unlimited patience, intelligence, and loving passion that inspires every breeder worthy of the title. It is this same passion that

enabled the first herdsman to refrain instinctively from slaughtering the calf, the lamb, or the piglet whose gait and character made it ideal breeding stock. He was able to perceive that the animal's lineage could subsequently be improved from one generation to the next by experimental crossbreeding and by simple trial and error.

That is what animal breeding is mainly about—aiming for perfection without ever forgetting that, no matter how splendid the animal produced, its genes can always be used to obtain a more perfect offspring. This is the way animal breeders over the centuries have developed and improved the various breeds of horses, cattle, pigs, and sheep. All have become progressively more refined, because such was their breeders' aim.

Cloning is something else entirely. In the name of science, it arrests animal evolution. It creates a kind of living replica, rather like a mass-produced reproduction of the Venus de Milo. Where the original statue inspires us with great emotion, even the most accurate copy appears bland and lifeless. I do not mean to condemn cloning, which is, after all, the fruit of human intelligence and, in a sense, the ultimate achievement of biological science today. What I deplore is the way these techniques are used, because the products thereof are of no interest to breeders such as I once was. I must confess that I find these laboratory calves and lambs unattractive, unclearly formed, and ultimately questionable; indeed, they are already mature at birth! In fact, I am wary of these fatherless offspring, these fruits of cellular manipulation, and the idea that they are celebrated as strictly identical

copies of their mothers does not alter my opinion. For a genuine breeder the most desirable quality in a ewe or a cow is far more than beauty; it is the ability to produce progeny of even greater beauty, which will in turn contribute to the evolution of the line by producing offspring of similar perfectibility.

So it is my hope that cloning will be restricted to the laboratory as an experiment and that scientists will not attempt to increase the applications of this type of activity. Consider the tragedy of mad cow disease. Numerous animals have already died—and will die in the future—because of the regrettable innovations of supposed animal-nutrition experts: in the dubious name of profitability, they fed cattle on fodder derived from animals slaughtered because of an incurable illness, and they managed to create a new incurable illness in the process. These somber remarks are intended to remind us that the animals shown in these pages are the result of careful selective breeding, not of laboratory experiments for the sake of scientific innovation or economic efficiency.

I hope the author will forgive me for once again paying tribute to farmers throughout the world who have successfully pushed their animals to their utmost distinction, who have made them not just worthy subjects for these photographs but also—and every breeder will understand this point—eligible for a starring role in livestock shows on an international level. Without these exceptional breeders, this album would not exist. If I belabor this point, it is because I understand the patience, the hard work, and the expertise required to start with a newborn animal,

of whom you know only the ancestors, and then to spend several years raising it to become a bull weighing more than a ton or an extraordinarily productive milk cow; a ram or a goat of exceptional beauty and strength; a stallion or a mare of championship mettle; a boar or a sow whose size and shape take your breath away.

You do not have to be a professional breeder to appreciate the beauty of the subjects captured by these photographs, although specialists are, of course, better qualified to judge and appreciate their proportion, shape, weight, and gait. An expert in bovine breeding will immediately be struck by the Holsteins and other milking breeds, which are notable for their magnificent grafts and enormous "milk fountains" (the mammary veins of the udder), and by their distinctive shields, or patterns of variable shape and surface formed by the hairs on the perineum of milk cows. Likewise, anyone who has ever bred rams and boars will surely be awestruck by the breathtaking beauty and power of the specimens shown here. The horses, too, are exemplary: the extraordinary musculature and sturdy legs of the draft horses and the elegance of body and limb in the lighter breeds, evidence of their aptitude for speed.

It is not, of course, necessary to be an art critic in order to admire a painting, a musicologist to enjoy a symphony, or a gram marian to love literature. And we who are not experts can delight in the sight of these animals simply because they are magnificent, even if we do not know their breed, their function, or their country of origin. So let us look at these photographs, which reflect a high level of art and skill on the part of the photographer. The great

professional that Yann Arthus-Bertrand obviously is—I do not know him personally—has hidden himself behind his camera in order to let his subjects speak for themselves. Moreover, in order to avoid distracting the reader's attention from the animals by a lovely landscape in the background, or a spotless stable or sty, the photographer has deliberately avoided the use of contrived scenery, flamboyant sunsets, lush prairies studded with grazing sheep, and racetracks electric with Thoroughbreds pounding toward the finish. We have none of that here, just a plain dark backdrop, adequate lighting, and the stars themselves.

But the stars are not only the animals. Arthus-Bertrand clearly realized that a series of livestock portraits would soon become tedious, in spite of the beauty of the beasts. And thus we are privileged to meet these magnificent prize-winning animals in the company of their breeders. It is heartwarming to see these men, women, and children of various nationalities and ages, all of them so proud, and with good reason, of the finest products of their respective farms. Although we may try to remain as coolly dispassionate as the judges who award the rosettes, ribbons, medals, and trophies that announce the superlative quality of these creatures, we cannot fail to be charmed by the presence, the attitude, and the expression of their human companions. I must confess that it was the human faces glowing with love and pride that encouraged me to write so many pages in their honor!

Aside from their undeniable artistic quality and the beauty of their subjects, these photographs are exceptional in revealing the evident complicity that has arisen between the animals

and those who present them to us. We sense that the trustful relationship between a bull, a boar, a stallion, or a ram and the person with whom he is posing is obviously the result of a long-standing reciprocal friendship.

While each photograph deserves our attention, and I personally love all of them, I must confess that I have a few favorites, with which the reader may or may not concur. Turning through these pages at random, I stop at the smiling little girl, all dressed in blue, who is caressing the muzzle of an enormous bull with her tiny hand. I can't help but think that the animal has had to acquire unusual confidence and docility to remain so gentle in the presence of such a sweet, but fragile young farmer.

I also particularly like the picture of the men who are happily kissing their milk cows, but I am drawn as well to the image of the man in a red sweater who laughingly recoils before his bull's demonstration of affection gets out of control: here, it is the animal who wants to do the kissing!

And then there are the two men—one wearing a blazer, a tie, and a flower in his buttonhole, the other in shirt sleeves—calmly seated next to an impressive mountain of muscles. One dangles a lead rope between two fingers, a mere prop for the sake of the photograph. Another favorite is the young woman, undoubtedly English, who is dressed for an elegant dinner party but stands proudly next to a prize bull whose jowls are bedecked with victory ribbons.

Rounding out the bovine family, I find immense pleasure in the photograph of the young couple totally relaxed in the com-

pany of their amiable bull, who must weigh more than 2,500 pounds. He gracefully provides a practical leaning post for the farmer and a broad back on which the farmer's wife can comfortably recline. Isn't that a perfect demonstration of domestication in the finest sense of the word?

But I must not overlook the photograph of the two beaming women, one with a champion cow and the other with a prize boar. The first has adorned her hat with the prize ribbons of her cow, against whom she is leaning, while the other farmer is dressed all in black and glowing with pride, like the boar she is showing. And who could fail to smile at the sight of the small boy bursting with joy as he leans against his massive sow?

I must also mention the marvelous, immensely likeable man with the extraordinary beard who fondly hugs a formidable ram with enormous horns. Magnificent also is the old, white-bearded shepherd, still wearing the sturdy shoes he needs to follow his flock across the moors, who poses proudly here behind his prize ram. Of the father posing with his two sons, it is difficult to say which of the three is the happiest; the ram in the picture, which is held with barely one finger, clearly knows which of the four is the most beautiful. It is not difficult to guess the provenance of the wool in the warm sweaters being worn by the smiling couple who are thrilled to share the spotlight with their prize animal, as they share with us the pleasure they take in being its breeders.

At last, and I will stop here, my heart goes out to the young woman who kneels in front of a ewe with two newborn lambs at

her feet. Thoroughly astonished to be there, one of the babies stares in wonderment at the camera, while the other hesitates between its mother and the young woman. I feel that this peaceful, gentle scene summarizes perfectly what breeding is all about: a beautiful mother, two offspring already eager to prove their mettle, and a capable young breeder prepared to devote herself to ensuring the excellent comportment and well-being of her animals as she constantly works to improve their bloodlines.

These are the photographs that I find most remarkable in Yann Arthus-Bertrand's work, although it was not easy to leave any out. Readers will surely pick their own favorites, undoubtedly finding some more charming than others. One thing is certain, however: no one can remain indifferent to the animals immortalized in these pictures. For my part, I know that I will often pick up this book and thumb through it with nostalgia for those cattle and sheep I once bred, knowing that I can always evoke their memory in these remarkable images.

—Translated by Anne Norris

Breeds

Although some readers may regard this as a photography book, many will view it as a valuable pictorial record of some of the most highly bred examples of domestic livestock, especially those of Europe and Argentina, where the photographer's interest in animals drew him to local agricultural shows, similar to the county fairs that are such a popular attraction in rural America. Some of the breeds pictured here are raised in the United States and elsewhere, while some are completely unknown beyond the small local region in the country where they originated and are still raised today. Even the same breed can exhibit different traits in different regions, usually because of the introduction of genetic material from other breeds or types in order to enhance desirable qualities, such as size, milk production, temperament, or whatever. Sometimes the crossing of two established breeds can result in a new breed, whereas sometimes it simply improves an existing breed, but the process can be confusing for readers who may not be familiar with the terminology used in the breed descriptions that follow. For them we offer a brief explanation.

Generally speaking, animals that share characteristics as a result of selective breeding and that pass these on consistently to their progeny can be considered examples of a true breed. A breed is usually established through the formation of a herd book, which keeps track of all breeding stock and sets standards for various traits. When there are only a few animals in a particular breed, the genetic material becomes limited, so that certain traits may be exaggerated or lost altogether; some breeds even become extinct or so rare that they cannot be saved, at least not as purebreds, and some breeds traditionally used for one

purpose may be selected to serve another. Breeders, therefore, will often use males or females from different breeds to enrich the gene pool of their own animals, and the results are often spectacular, as one can see in these photographs. More remarkable, however, is the clear demonstration here of the reasons breeders make such an effort to preserve rare and endangered breeds. The Holstein, for example, is a highly efficient milk producer in many climates, and the population of cows is huge worldwide. However, if anything were to threaten the Holstein, such as a drastic climate change, the unavailability of certain foods, or the emergence of a breed-specific disease, breeders would need access to the special traits of other bovine breeds that are resistant to heat, disease, or parasites or that can produce good milk on a diet of grass rather than grain.

Note that the following breed descriptions are specific to the country in which the animal was photographed, so that the breed characteristics and population statistics are local, although the breed may exist in other countries, including the United States. For easy reference, the international breed name is used as the primary name, with some local variations given in parentheses. Those who are interested in learning more about any particular breed are encouraged to address queries to the Department of Animal Science of Oklahoma State University (www.ansi.okstate.edu/breeds), which maintains a data base of many international breeds and breed registries, as well as links to other sources of information.

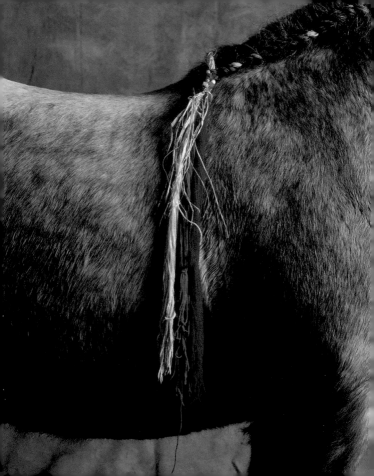

Horses (*Equus caballus*)

ANGLO-ARAB p. 104

Origin: Limousin, France;
 studbook established 1941
Distribution: Europe
Population: 2,200 broodmares in France
Height at the withers: 16 to 17 hands
Color: Bay, chestnut, or gray

The Anglo-Arab is the product of a cross between the English Thoroughbred and the Arabian, which first took place officially in the mid-nineteenth century in the Limousin region and in southwest France; to this cross was added a local breeding stock, also the result of a Thoroughbred-Arab cross. Anglo-Arabs are still raised in the same area, near the Haras de Pompadour, a national stud farm; they are also raised in fairly large numbers in the Compiègne and Angers regions.

The Anglo-Arab's speed and aptitude for jumping, along with its elegance and stamina, make it a valuable horse for three-day eventing, dressage, and endurance riding. In southwestern France Anglo-Arabs are also trained intensively for both flat racing and steeplechasing. Their height, way of going, and physical endurance, however, also make them fine saddle horses, useful for both instruction and trail riding.

ARDENNES (also Ardennais) pp. 48, 101, 108

Origin: Eastern and northeastern
 France; studbook established 1929
Distribution: National
Population: 1,130 broodmares in France
Height at the withers: 15.5 hands and over
Color: Varied, including bay or roan (no black)

The Ardennes, probably a descendant of Solutrean horses, is one of the oldest breeds of draft horses in France. From the Roman era to the nineteenth century, they answered the requirements of both war and agriculture, possessing stamina, strength, a hardy physique, and a temperate nature. Ardennes are raised as purebreds in the northeast quarter of France, specifically in Champagne-Ardenne, Lorraine, and Alsace, although they can be found in the Massif Central and the Pyrenees as well. Compact, stocky, low to the ground, and docile, the Ardennes is still used as a draft horse for certain agricultural or specialized tasks, such as pulling wagons in vineyards and pulling tourist carts and carriages.

AUXOIS

pp. 30, 184

Origin: Auxois in northern Burgundy, France;
 studbook established 1913
Distribution: Regional
Population: 260 broodmares in France
Height at the withers: 15.5 to 16.5 hands
Color: Bay or roan (also dun or chestnut)

 Closely related to the Ardennes, the Auxois is the product of cross-breeding between local Burgundian mares and Ardennes stallions, especially the Trait du Nord, or Northern Draft Horse, with some infusion of Percherons and Boulonnais blood during the nineteenth century. The breed is native to the Auxois region, which includes all of southwestern Côte d'Or and some of the Yonne and Saône-et-Loire departments. This fertile area of rolling hills and rich pastureland has produced a breed that tends to be both tall and massive.

Despite their small numbers, Auxois horses have always been prized in the agricultural sector. Their great strength makes them good draft horses, but they are also used for hauling timber and for pulling tourist vehicles, especially caravans in the Morvan mountains.

BOULONNAIS

p. 124

Origin: Northern France;
 studbook established 1886
Distribution: Regional
Population: 495 broodmares in France
Height at the withers: 16.5 hands
Color: Gray, chestnut, or bay

 This type of horse is mentioned in chronicles of the seventeenth century, when the Desvres foal fair was instituted. The origin of the breed is sometimes associated with Caesar's cavalry, which used North African horses from Numidia when they gathered in 54 B.C. near Boulogne on the English Channel to embark for England. This Arabian blood was reinfused several times—during the Crusades, the Spanish occupation, and the First Empire. Boulonnais breeding horses are recorded in a number of departments in northwestern France, principally Pas-de-Calais, Nord, Somme, Seine-Maritime, and Oise. Today its small population has made it a genetically preserved breed, but one that is not, unfortunately, being raised abroad.

The Boulonnais is energetic and active and has brilliant gaits; it is an excellent draft horse whether for work or competition. It is highly prized for the elegance of its teams and participates successfully in racing, both ridden and driven.

BRETON COACH

pp. 164, 263

Origin: Brittany, France;
 studbook established 1909
Distribution: National
Population: 3,500 broodmares in France
Height at the withers: 14.3 to 16 hands
Color: Chestnut or dun (also bay or roan)

 Today's Breton horse is the product of a long process of selection by breeders using ancient varieties of local horses. The eighteenth and nineteenth centuries witnessed much crossbreeding intended to improve these varieties; the most famous and the most successful resulted from the mating of Norfolk stallions imported from Great Britain with mares from Léon. The Breton Postier, or Post-Horse, whose reputation spread throughout the world, was a result of this crossbreeding. Originally raised in the four departments of Brittany and in Loire-Atlantique, this horse is found far beyond the traditional birthplace of the breed. Bretons today, both the lighter Postier Breton and the heavier Breton Coach, can be found throughout France, especially in the mid-mountain regions of the Massif Central and the Pyrenees; they have also been widely exported, even to Japan.

Endowed with an energetic gait and a remarkably docile temperament, the Breton is ideal for driving, farm work, and pleasure. When trained early, Breton foals will remain very affectionate and gentle throughout their lives. Furthermore, unlike other draft breeds, the Breton has never stopped being used in harness and is still employed in agriculture for precision work in the raising of vegetables.

ARGENTINE CRIOLLO
(also Criollo)

pp. 20, 22,
60, 275

Origin: Argentina
Distribution: International
Population: Moderate
Height at the withers: 14 to 14.3 hands
Color: Yellow-dun, roan, chestnut, piebald,
 or shades of gray or brown-dun

 The name Criollo, which encompasses various populations of South American horses (Brazil's Crioulo Brazileiro, Venezuela's Llanero, and the Argentine Criollo), means "of Spanish origin." The Argentine Criollo descended from the first Andalusian horses, in which Barbary blood predominated and which the Spanish conquistadores introduced into South America. These Andalusians were infused with local Sorria blood. The Criollo's coat varies greatly from one animal to the next, from solid chestnut to roan to piebald.

This robust, strong-limbed breed has adapted to a difficult environment on the pampas in Argentina, with rough pasturage and a wide range of temperature. Because of its remarkable stamina—it probably has greater endurance than any horse in the world—the horse has always been used to carry heavy loads over long distances. The Argentine Criollo is also the army's saddle horse of choice, as well as that of gauchos, and has been crossed with European and North American breeds to improve its speed.

FRIESIAN p. 38

Origin: Friesland;
 French studbook established 1879
Distribution: Europe
Population: Moderate
Height at the withers: 15 to 15.3 hands
Color: Black

 Known since antiquity for its endurance, economical maintenance, sturdiness, and docility, the Friesian acquired Arabian and Andalusian blood during the Crusades and later, during the Spanish domination of the Netherlands, in the sixteenth and seventeenth centuries. Because they are small and powerful in the shoulders, Friesians were considered the best and least expensive of European war horses. Because they are adaptable to a number of uses (harness, saddle, farm work), they have also been used as purebred stock to improve other breeds. Many horses, especially in Great Britain, have descended from the Friesian, including the Shire. A studbook was created in 1879, but by the beginning of the twentieth century Friesians had virtually disappeared because of massive crossbreeding to improve their speed. They were saved by gas rationing during World War II, which led to a revival of horse-drawn vehicles, and they are now used as fine carriage horses in competitive events and for pleasure driving.

HACKNEY HORSE p. 188

Origin: Norfolk, England;
 studbook established 1833
Distribution: International
Population: Small
Height at the withers: 14.5 to 15.5 hands
Color: Bay, brown, gray, black, or roan

 A descendant of the Norfolk Trotter, and in lesser measure of the Yorkshire Trotter—two great original lines of many breeds of European and North American horses—the Hackney is a very attractive harness horse, largely because of its animated gaits. The association of Hackney breeders was founded in 1883, but lack of interest in this breed in the early 1940s caused it nearly to disappear. However, by the end of World War II, the popularity of horse shows and the resurgence of interest in trotting races led to the breed's survival. Hackneys have been exported to the United States since the early nineteenth century and have contributed much to the improvement of the American Standardbred. There is also a Hackney Pony, which is very similar in appearance but much smaller.

PERCHERON

pp. 28, 180, 232

Origin: Perche (now Orne and Sarthe), France;
 studbook established 1883
Distribution: International
Population: 1,756 broodmares in France
Height at the withers: 16 hands and over
Color: Gray or black

The origins of the Percheron appear to be ancient, but the development of the modern breed was strongly influenced by the infusion of Arabian blood, beginning in the eighth century and periodically thereafter, so that the Percheron has been described as an "Arabian enlarged by the climate and by the hardiness of the uses to which it has been put for centuries." Many types of Percheron coexist today, which is one of the breed's great strengths.

The birthplace of the breed lies between the towns of Mortagne-au-Perchy and La Ferté Bernard in southern Normandy, but Percherons are found in a great many regions in France, as well as in numerous foreign countries (the United States, Japan, Germany, Great Britain, and others), to which they continue to be exported. In the United States, Percherons were very popular for farming, and a number of breeders, including Amish farmers, have done much to help preserve the breed.

Percherons are wonderful draft horses, capable of intense effort. Their power, gaits, appearance, and gentleness make them very good harness horses, and they are excellent farm animals, especially for pulling vehicles.

ARGENTINE PETISO PONY

pp. 4, 236, 261

Origin: Argentina
Distribution: National
Population: Moderate
Height at the withers: 12 hands
Color: Varied

Argentine Petisos are a new type of pony, a cross between Shetland and Welsh ponies that were imported by Argentine breeders after World War II. The cross was improved by the introduction of Criollo blood, which contributed sturdiness, conformation, and color. The Argentine Petiso, halfway between the Welsh and the Shetland in size, is used for riding.

ARGENTINE POLO PONY p. 239

Origin: Argentina
Distribution: International
Population: Moderate
Height at the withers: 15 to 15.5 hands
Color: Varied

Argentina is internationally famous for its polo ponies, which are specially bred for the sport, now played on all five continents. Evidence indicates that polo was played in Persia at the time of Alexander the Great and Darius.

Argentine polo ponies are not a breed of ponies, but a population of Argentine Criolo horses improved with Thoroughbreds from North America to produce a pony with remarkably strong legs, great vitality, and the ability to turn, stop, and accelerate very quickly. Only animals that have demonstrated their quality on the field are used to produce new generations.

SELLE FRANÇAIS p. 127
(also French Saddlebred)

Origin: Normandy, France;
 studbook established 1963
Distribution: European
Population: 12,000 broodmares in France
Height at the withers: 15.3 to 17.3 hands
Color: Chestnut, bay, roan, dun, or gray

The Selle Français is a breed whose name dates from 1958. It was produced by crossing Norman mares and English Thoroughbreds, hence its earlier names Anglo-Norman and Half-Bred. The breed originated in the département of Manche, around the national stud farm, Haras de Saint-Lô, and more widely in lower Normandy. There are also many stud farms in the east-central part of France (in the area around Cluny), as well as in the east and north, but breeding farms exist throughout the country and increasingly in the United States.

The Selle Français is particularly prized as a sport horse both in France and abroad, where it competes on international jumping teams and in combined-training events. Some near-Thoroughbred members of the breed are trained for races designated "Other than Thoroughbred" (Autre que Pur-Sang). The Selle Français is also often found in riding establishments, because it is for the most part a comfortable, good-natured horse.

SHIRE p. 16

Origin: Eastern England;
 studbook established 1878
Distribution: National
Population: Moderate
Height at the withers: 17 hands or over
Color: Black (also bay or gray)

Shire horses are native to the Fens, in eastern England, and are a cross between the local populations of draft horses—the so-called "Great Horses" ridden by knights—and stallions principally from Flanders. The Shire also has Friesian, German Draft, and Flemish blood, the last from the first half of the seventeenth century. A little lighter, shorter, and slower than its ancestors, the Shire became the preeminent draft horse of wartime and peacetime, country and city, in fields and on unevenly paved roads.

This breed of very powerful horses was exported in great numbers to the United States in the early twentieth century, but the development of motor vehicles resulted in a considerable reduction of the population. However, in both America and England today, Shires are raised for show and parades, and for events such as pulling large beer wagons and competing in the great London draft-horse race.

ITALIAN HEAVY DRAFT p. 203

Origin: North and central Italy
Distribution: Regional
Population: 8,000 broodmares in Italy
Height at the withers: 15.5 hands
Color: Chestnut

Native to north and central Italy, Italian Heavy Draft horses are renowned draft horses that are also raised today for their meat. The local stock has been successively improved since the nineteenth century by crossbreeding with Belgians, Percherons, Boulonnais, and especially Bretons. Hardy, inexpensive to maintain, docile, and strong, these horses are perfectly suited to the work required on small Italian farms. The farmers greatly prize the horses' speed and lively trot, which have earned them the nickname "swift heavy draft." These horses are quick to mature, which adds to their value as workhorses and meat producers.

PYRENEES MULE

p. 271

Origin: Hautes-Pyrénées, France
Distribution: International
Population: A few hundred
Height at the withers: 14.5 hands
Color: Gray, brown, or black

A cross between a donkey and a mare, the Pyrenees mule seems to have originated in the Roman era, when it was used in southern Europe for carrying loads. During the thirteenth century, principally in the south of France, the breeding of mules increased because of the region's general industrial development. This animal was used regularly until World War I, but its population decreased with the use of motor vehicles. France continued to produce mules until the 1950s, largely for export to Africa and South America.

In the Pyrenees these mules are raised on the Lannemezan plateau, where the native soil, along with the skill of breeders, has produced robust, docile animals with great stamina. Mules, which are hybrids and thus unable to reproduce, are longer-lived than horses and much less expensive to maintain. Today mules are commonly used as pack animals on excursions, but they can also be ridden.

POITEVIN MULE

p. 170

Origin: Poitou and Vendée, France
Distribution: International
Population: 250
Height at the withers: 15 to 16 hands
Color: Brown chestnut, dark gray, or dun

Poitevin mules represent a cross between the Poitevin Mulassier (mares from the marshy district in Vendée used for breeding mules) and the Poitou Burro (or Baudet de Poitou). There were several thousand Mulassier horses at the beginning of the century, but the population declined to 250 individuals in 1994 and today is a protected breed. Mulassiers are powerful, big-boned, large-hoofed draft horses that stand 15.5 to 16.5 hands and vary in color from black and bay to gray. Poitou Burros are a very old breed of donkey whose origins remain a mystery. In 1980 the breed numbered only some sixty individuals and was granted a protected status; in 1994 there were more than two hundred burros in France and abroad. The Poitou Burro is calm, strong, and characterized by its brown-bay hair and long wisps of coarse hairs. The male stands 14.5 and the female 13.5 hands.

Poitevin mules, well built and robust, are remarkable draft, pack, and harness animals. Before World War II, more than ten thousand mules were produced a year, compared with about one hundred today.

COTENTIN DONKEY pp. 183, 243

Origin: Normandy, France
Distribution: Regional
Population: Small
Height at the withers: 12.5 hands
Color: Gray

For a great many years these donkeys were bred in Normandy, particularly in the Cotentin region, for transporting milk and pulling agricultural implements. Although mechanization has reduced the number of donkeys in all areas, the Cotentin has maintained a local population that in recent years has been included in the French studbook under the breed name Cotentin Donkey. Generally speaking, this donkey is a bit larger than other Norman donkeys, but it has a very docile temperament that makes it a fine companion and recreational animal. In Normandy it has also come to be used for walking tours. Like many other breeds of donkey, the Cotentin has a Saint Andrew's cross on its back and may or may not have stripes on its legs.

GRAY PROVENÇAL DONKEY p. 115

Origin: Provence, France
Distribution: Regional
Population: 270 jennets in France
Height at the withers: 12 to 13 hands
Color: Gray

Provençal donkeys originated in the fifteenth century, in association with the raising of the sheep that migrated between the valleys and the mountain pastures of what is now Alpes-de-Haute-Provence and the Dauphiné region. During these great migrations, these donkeys carried equipment and food for the shepherds, salt for the ewes, and even the lambs born en route. They are very robust, remarkably docile, and well equipped physically for the difficult terrain. These donkeys, like many other donkey breeds, have a cross on their dove-gray coat, which ranges from light to dark, and sometimes zebra markings on their legs.

Mechanization has led to a significant decrease in the population; the number of Provençal donkeys is today estimated at not quite three hundred. The last few years, however, have begun to see a significant demand for them as pets, for carrying baggage or children on walking tours, and for vegetation management.

Swine (*Sus scrofa*)

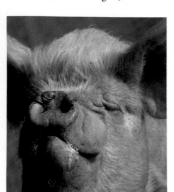

and Goats (*Capra hircus*)

BERKSHIRE p. 163

Origin: Berks, England;
 herd book established 1884
Distribution: International
Population: Fairly large
Weight of boars: 550–660 pounds;
 of sows: 440–550 pounds
Color: Black

The Berkshire breed was created in England in the 1830s from a cross between local stock and Chinese and Neapolitan pigs; the objective was to combine in a single animal the high quality of meat in the local and Neapolitan pigs with the reproductive quality of the Chinese pigs. Berkshires have a black coat with six white points: the snout, the underside of all four feet, and the tip of the tail. The sows have good maternal qualities and produce piglets that grow quickly, although that sometimes results in lightweight carcasses because of their precocity. Outside the United Kingdom, the breed is raised in North America and Oceania.

NORMAN pp. 34, 75, 138
(also Blanc de l'Ouest, Western White)

Origin: Western France;
 herd book established 1958
Distribution: Regional
Population: 150 sows in France
Weight of boars: 950 pounds;
 of sows: 770 pounds
Color: White

 The common origin of the Craonnais, Norman, and Flemish breeds and of the types derived from them led to their being grouped and merged in 1958 under the single name of Blanc de l'Ouest (or Norman). Pigs in this group, which is Celtic in origin, have a white coat, a dished face, and ears that flop forward, hiding the eyes. They are currently raised in Normandy and Brittany. The Blanc de l'Ouest has recently undergone a resurgence in Brittany, thanks to the breed-preservation project of the Institut Technique du Porc, which began in 1981.

This large pig (39 inches at the withers) is well adapted to outdoor breeding. Their prolificacy is average. The quality of the meat is good and known for its use in charcuterie.

JERSEY DUROC p. 251
(also Duroc, Duroc-Jersey)

Origin: Eastern United States
Distribution: International
Population: Large
Weight of boars: 660–770 pounds;
 of sows: 550–660 pounds
Color: Red-brown

 The Jersey Duroc breed was created in the United States in the 1840s by crossing the early Duroc breed of New York with a related breed, the Jersey Red of New Jersey, in order to obtain hardy animals that would fatten, or finish, quickly on grain. The sows are prolific, and the piglets grow very quickly.

GLOUCESTER OLD SPOT p. 10

Origin: Central England;
 herd book established 1915
Distribution: United Kingdom
Weight of boars: 660–770 pounds;
 of sows: 550–660 pounds
Color: White with black spots

Gloucester Old Spots are the result of an improvement made early in the twentieth century of a local population in central England. The drooping ears of these pigs fall forward, and their white coats display black spots that vary in number and size. This prolific and very hardy breed was used especially in crossbreeding to improve carcass quality but found rivals among the other breeds when pig-breeding became industrialized. Outdoor farms continue to raise Gloucester Old Spots today, however, because of their great hardiness and their maternal qualities.

LANDRACE GILT p. 135
(also Belgian Landrace)

Origin: Northern Europe; Belgian herd book
 established 1920; French herd book 1952
Distribution: International
Population: 3,600 sows in France
Weight of boars: 770–990 pounds;
 of sows: 572–660 pounds
Color: White

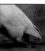

The various European Landrace populations are the result of crossbreeding between Large Whites and northern European breeds of the Celtic type. After a period of uncertainty in the 1970s about whether the sows or the boars should be used as breeding stock, the Landrace's importance today clearly depends on its female stock. The breed is highly regarded for its capacity for growth, less so for its lean-meat yield. The quality of the meat is very good.

The Landrace's principal function is to partner the Large White in order to produce the Large White-Landrace breeding sow, which is the most widespread genetic type in French pig breeding. This sow is very prolific and contributes to France's position as the number-one European pig-breeding nation.

LARGE WHITE pp. 27, 32, 119, 157
(also Yorkshire)

Origin: Yorkshire, England; U.K. herd book
 established 1884; French herd book 1926
Distribution: International
Population: 6,000 sows in France
Weight of boars: 880–1,100 pounds;
 of sows: 616–770 pounds
Color: White

This very popular international breed originated in the county of Yorkshire, in northeastern England. In 1920 the Large White was introduced into France, where it has developed a very good reputation. This is the epitome of a female breed because of its great productivity, which has been even further improved in recent years for a very specific type. The breed is much in demand today, and exports are increasing.

Of all the breeds, the Large Whites have improved the most in terms of growth performance, they are distinguished as well by the high quality of their meat. They display good adaptive qualities and strong legs, which make it possible for them to be raised under diverse conditions. Large Whites are central to French pig production. They are crossed with French Landraces to obtain the Large White-Landrace crossbred sow, which is the breeding sow most used in France. In many breeding operations, Large Whites are also involved in the production of boars crossed with Piétrains.

MIDDLE WHITE pp. 136, 139

Origin: England; herd book established 1884
Distribution: Local
Population: 150 pigs in England (protected)
Weight of boars: 550–660 pounds;
 of sows: 440–550 pounds
Color: White

Middle Whites are the result of a mid-nineteenth-century cross between local English and Asian pigs. They are small, with a uniformly white coat, and are characterized by a very short, wrinkled, and turned-up snout. Middle Whites have been used either as purebreds in the breeding of light pigs (150 pounds on the hoof) or occasionally crossed to produce bacon pigs (200 pounds on the hoof). The breed exists today in very small numbers and is in conservation.

Origin: England; herd book established 1884
Distribution: Local
Population: 250 pigs in England
Weight of boars: 660–770 pounds;
 of sows: 550–660 pounds
Color: Red-brown

 Tamworths, the result of a mid-nineteenth-century cross between a local English breed and an Iberian type, are characterized by a coat of red bristles. This is a very hardy breed, although performance in terms of reproduction, fattening, and carcass is modest, which explains why Tamworths have all but disappeared from pig breeding.

Origin: The Alps;
 French herd book established 1930
Distribution: International
Population: 450,000 does in France
Weight of bucks: 175–220 pounds;
 of does: 130–175 pounds
Color: Buff

 The Alpine breed is native to the Swiss and French Alps. Although the buff variety is the most widespread, there is also excellent multicolored stock and strains with solid white, brown, and black coats. During the last eighty years, Alpine goats have been introduced into several regions of France, especially Poitou-Charentes and the middle valley of the Loire and its affluents. They are also raised in the Saône and Rhône valleys, important goat-cheese-producing areas, like Haute Savoie, where the breed originated. Today the Alpine breed is the most populous goat breed in France, followed by the Saanen, also a short-haired breed, but with a solid white coat. The French Alpine has been exported to the United States.

Alpine goats are good milk producers of medium size (29 1/4 inches at the withers), with an average lactation of 1,417 pounds of milk in 276 days. They are hardy and adapt equally well to stabling and to pasture grazing and life in the mountains.

MALAGUEÑA
(also Malaga)

p. 162

Origin: Andalusia, Spain;
 herd book established 1984
Distribution: Southern Spain
Population: More than 200,000 does in Spain
Weight of bucks: 143–154 pounds;
 of does: 110–121 pounds
Color: Red-brown

The Malagueña goat from southern Spain is an animal of average size (the does reach a height of 25 ½ inches at the withers); the coat is red-brown, its darkness varying from herd to herd and from one individual to another. The females are early to mature (producing their first kids at the age of one year), prolific (1.8 to 2 kids per kidding), and good milk producers, their average lactation production exceeding 1,100 pounds over 240 days. Herds of this breed are utilized either for milk production, especially on the Spanish coast, where there is good fodder, or for meat, in the more rugged areas inland.

LE ROVE

p. 151

Origin: North of Marseilles, France
Distribution: Regional
Population: 1,500 does in France
Weight of bucks: 175 pounds;
 of does: 130 pounds
Color: Brown

Rove, a small village near Marseilles, gave its name to this attractive and hardy breed of goat, made famous by its brousse du Rove cheese, and the breed is still raised in the Alpes-de-Haute-Provence-Côte d'Azur region. Used for centuries to lead the herds in summer to their mountain pastures, this breed is exceptional for its cheese and for the maternal qualities of the does, which are excellent mothers to orphan kids as well as their own.

The ability of the Rove goats to sustain themselves by grazing makes them economical to maintain; they are also environmentally sound (clearing undergrowth, fire control, etc.). Thanks to the great muscularity of the buck, the Rove is used in crossbreeding to improve conformation.

Cattle (*Bos*)

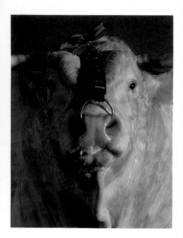

ABERDEEN-ANGUS
(also Angus)

p. 99

Origin: Scotland; U.K. herd book
 established 1842
Distribution: International
Population: Large numbers in many countries
Weight of bulls: 1,870 pounds;
 of cows: 1,210–1,320 pounds
Color: Black

A native of eastern Scotland, the Aberdeen-Angus breed can be recognized by its black color and absence of horns. The breed is one of the most widely utilized throughout the world for the production of beef; its heavily marbled flesh is a favorite with consumers. For more than a century, Angus have been imported to all the great cattle-raising regions, including North and South America (especially the United States and Argentina), Oceania, and South Africa. The American Angus Association records more cattle each year than any other breed association, making it the largest beef registry association in the world.

A rugged animal of medium size, the Angus cow offers fine maternal qualities, with sufficient milk production to enable her calves to reach full genetic potential. For this reason, the Angus is often crossbred with the Hereford in order to produce an F1 female, which is also remarkable for maternal qualities, excellent adaptability, limited size, the ability to calve easily, and good milk production.

ARGENTINE HOLANDO
(see Prim'Holstein)

ABONDANCE p. 8

Origin: Haute-Savoie, France;
 herd book established 1894
Distribution: Regional (southeastern France)
Population: 55,000 cows in France
Weight of bulls: 1,870–2,420 pounds;
 of cows: 1,275–1,500 pounds
Color: Red and white

 The Abondance, a breed in the Pie Rouges des Montagnes group, has been selectively bred for many years in a valley of the same name in Haute-Savoie. A hardy dairy cow, this medium-sized breed is well adapted to the optimum exploitation of mountain pastures. Rich in protein, its milk is used for making Reblochon, Abondance, and Beaufort cheeses, some of which enjoy the *Appellation d'Origine Contrôlée* label, indicating high quality.

The Abondance is currently bred in thirteen departments, principally in the Rhone–Alps region but also in the Massif Central. It is estimated that there are 50,000 head today, a number that has greatly decreased in recent decades.

AUBRAC pp. 55, 187, 217
(also Laguiole)

Origin: Southeastern France;
 herd book established 1892
Distribution: Regional
Population: 65,000 cows in France
Weight of bulls: 1,870–2,420 pounds;
 of cows: 1,210–1,540 pounds
Color: Fawn

 A native of the Aubrac region, where it was traditionally used for milk and farm work, this breed is primarily used today for meat production. The result of careful selection in a difficult environment that allows for summer grazing in mountain pastures and a long winter confined to the barn, the Aubrac has acquired rugged qualities and excellent maternal characteristics: fertility, easy calving, and longevity. The breed is thus well adapted to modern needs, such as making optimum use of extensive open spaces, which contributes to landscape management. The meat-producing capacity of Aubrac calves—their growth rate and conformation—is often improved by crossbreeding the cows with Charolais bulls.

Origin: Central Pyrenees region, France;
 herd book established 1919
Distribution: Local
Population: 110 cows in France
 (in conservation)
Weight of bulls/cows: 1,325 pounds
Color: Chestnut

The Aure et Saint-Girons breed is still called Casta by breeders, because the color of the hide is reminiscent of chestnuts (from the Latin *castinea*). This very old dairy breed from the central Pyrenees was once also used for farm work. It is very rare today and in conservation, as the population is very small and spread over only about twenty farms in the southern Ariège, Hautes-Pyrénées, and Haute-Garonne departments, where the cows are raised in a beef-production operation. The breed is valued for its hardiness, great longevity, easy calving, and remarkable maternal characteristics.

Origin: Scotland; U.K. herd book
 established 1877
Distribution: International
Population: 120,000 cows in Great Britain
Weight of bulls: 1,870 pounds;
 of cows: 1,210 pounds
Color: Red and white

A native of southwestern Scotland, the Ayrshire is a medium-sized, red-and-white breed with high milk-production capacity. Of special note are the superior shape and quality of the cow's remarkably formed udders and the fact that their milk is excellent for making butter and cheese. Ayrshire cows are satisfactory beef producers as dairy cattle go because their fat is not yellow in color, but this is improved by crossbreeding the cows with bulls of beef-producing breeds.

The Ayrshire breed has been exported to many other parts of the world, including North America, Australia, New Zealand, and South Africa. However, their numbers are declining throughout the world with the increased specialization of dairy production and the widespread development of the Holstein.

BAZADAIS
p. 229

Origin: Southwestern France;
 herd book established 1895
Distribution: Regional
Population: 2,500 cows in France
Weight of bulls: 1,760–2,200 pounds;
 of cows: 1,430–1,650 pounds
Color: Gray

 This breed comes from the Bazas hills and the Landes massif of southwestern France. The population of Bazadais cattle today has strongly declined, and a plan to reinvigorate the breed was launched in 1970. Today, there are 2,500 head in the southwest, an area extending from the Gironde River to the Pyrenees.

Used for farm work in the past, the Bazadais today has become specialized as a beef producer. The purebred Bazadais has been well known for its production of veal, but the breed also produces older animals for red beef. The marbled texture and the very fine grain of its meat are indications of tenderness and taste, which are highly prized by consumers.

BELGIAN BLUE
pp. 24, 71, 278
(also Belgian Blue-White)

Origin: Belgium; Belgian herd book
 established 1993; French herd book 1989
Distribution: International
Population: Leading breed in Belgium;
 nuclei in other countries
Weight of bulls: 2,750 pounds; of cows: 1,650
Color: White with black-and-white patches

 The Belgian Blue (called Blanc-Bleu-Belge in France) is the result of selecting for a beef-production conformation, which was begun in 1960 with a dual-purpose breed from middle and upper Belgium, and for the fixing of a gene for excessive musculature. As a result, the animals of this breed show extraordinary muscular development; they supply an extremely large quantity of meat at slaughter, and their carcasses offer a considerably higher percentage of high-quality cuts than those of all other breeds. Calvings in purebred cows, however, are almost always produced by Caesarian section.

Because of these characteristics, the animal is most often used as a pure-bred, principally in commercial crossbreeding in order to improve the conformation of calves. The Belgian Blue is being developed for this purpose in many countries, such as Great Britain, Spain, Colombia, and the United States, as well as France.

BLONDE D'AQUITAINE pp. 37, 42, 56, 72, 199, 244, 268

Origin: Aquitaine,
France; herd book established 1962
Distribution: International
Population: 370,000 cows in France
Weight of bulls: 2,200–2,970 pounds;
of cows: 1,540–1,910 pounds
Color: Wheat

Large in size, the Blonde d'Aquitaine from southwestern France is a beef cow that has resulted from the fusion of three old breeds in the 1960s: the Garonnais, the Quercy, and the Blonde des Pyrénées. In less than thirty years, the breed has become popular in many French regions, as well as throughout Europe, and it has been exported to many countries, including the United States. Today the Blonde d'Aquitaine is raised on the five continents.

The breed has characteristics that are extremely important for breeders who must confront the difficulties of modern cattle raising: great docility, numerous progeny, longevity, and butchering advantages—a good rate of growth and good conformation—which make it possible to obtain a wide range of finished products depending on the age of the animal at slaughter.

BRETON BLACK PIE p. 96
(also Breton Pie Noire)

Origin: Brittany, France; herd book established 1886
Distribution: Regional
Population: 650 cows in France (in conservation)
Weight of bulls: 1,100–1,540 pounds;
of cows: 770–990 pounds
Color: Black and white

The small Breton Black Pie breed was forged by the Breton climate and soil. Widespread in Brittany in the early 1900s, the breed was replaced by more productive stock in the 1960s, with the expansion of the Normande and the other Black Pie breeds. A plan to protect the breed was put into effect in 1976 which has made it possible to stop the decline in its numbers. For ten years now, there has been a increase in population, from 311 cows in 1975 to 650 today. This breed is used in Brittany and neighboring regions.

The Breton Black Pie is used either as a dairy cow, with farm-processed milk and direct sales of its products; or as a suckling cow, whose docile hardy characteristics are prized in the context of both extensive beef-production operations and smaller, independent farms that respect the environment and the value of soil development.

BRITISH WHITE

p. 158

Origin: England; U.K. herd book
 established 1918
Distribution: Local
Population: Limited
Weight of bulls: 1,850 pounds;
 of cows: 1,300 pounds
Color: White

The British White breed is quite remarkable for its color: the animals, genetically hornless as a rule, have a snow-white coat with black or red spots on the muzzle, the eyelids, the inside of the ears, the bottom of the hooves, and on the cows' teats. Because of this coloration, British Whites in the past were offered as gifts and were thus introduced into various royal courts.

At the beginning of the twentieth century, the British White was used as a decorative animal in stately parks and great landed estates; it was even called "the park breed" (not to be confused with the White Park breed, which is larger and has horns). Today the British White is raised for both milk and meat in the several herds that remain.

BROWN SWISS
(Brune des Alpes, Braunvieh)

p. 7

Origin: Switzerland; Swiss herd book
 established 1897; French herd book 1911
Distribution: International
Population: 30,000 cows in France
Weight of bulls: 2,090–2,530 pounds;
 of cows: 1,430–1,650 pounds
Color: Gray brown

Originally from the western part of Switzerland, the Brown Swiss has spread throughout central and southern Europe, and in the nineteenth century the breed was exported to North America, where it is probably the purest of all recognized breeds of dairy cattle. The Brown Swiss was also introduced into France in the nineteenth century; during the 1970s, American animals were imported for the purpose of breeding to increase size. Today there are 30,000 head of Brown Swiss cows in France, where they are raised essentially in the Châtillon region, but also in the Massif Central and the central and eastern Pyrenees.

The Brown Swiss is a dairy breed whose milk is rich in protein and produces excellent cheeses. The animals have adapted well to the climatic conditions of hot regions, as demonstrated by the international distribution of the breed.

CHAROLAIS

pp. 40, 193, 218

Origin: Saône-et-Loire, France;
 herd book established 1864
Distribution: International
Population: 2,050,000 in France
Weight of bulls: 2,200–3,080 pounds;
 of cows: 1,540–1,980 pounds
Color: White

 With over two million head in France alone, the Charolais is the country's premier beef-producing breed. Originally from Saône-et-Loire, the Charolais has spread throughout France since World War II; traditionally, however, there are two primary breeding regions: the northeastern part of the Massif Central and Vendée. A potent breeder used to improve stock, the Charolais has become highly esteemed in seventy countries on the five continents, where it has been used to increase the quality of primitively farmed beef-producing breeds, as well as to create new hybrids with the zebu, a domestic Indian bovine. Charolais bulls are also used in crossbreeding with dairy or hardy breeds in order to improve the conformation of calves.

In France, the Charolais has a great capacity for ingestion, which enables it to feed on rough fodder; it is thus perfectly adapted to being raised for meat production in open pasture. Of remarkable conformation, the purebred Charolais is a heavy animal that produces lean, slightly marbled beef much prized by butchers.

CHIANINA

p. 223

Origin: Tuscany and Umbria, Italy;
 herd book established 1963
Distribution: International
Population: Nuclei in various countries
Weight of bulls: 2,860 pounds;
 of cows: 1,540 pounds
Color: White to gray

 A very old breed once used for farm work and now raised for meat, the Chianina originated in Central Italy and has been selectively bred for many years for its large size and rapid rate of growth. The animal is off-white in color; the tip of the tail and the muzzle are black. The Chianina's conformation is excellent, but the forequarters in some animals may still be heavier than the hindquarters, a reminder that the breed was recently used for work in the fields.

Because of its very large size and its hardiness, this breed has also been exported to a number of large countries in North and South America, where cattle farming is extensive.

GASCON

p. 13

Origin: Central Pyrenees, France;
 herd book established 1894
Distribution: Regional
Population: 27,000 cows in France
Weight of bulls: 1,760–2,310 pounds;
 of cows: 1,210–1,540 pounds
Color: White to gray

Used for generations as a draft animal, the Gascon cow today is an especially productive nursing mother, either as a purebred or as a crossbred, in both difficult conditions and extensive cattle-raising operations. The Gascon today, numbering 27,000 head, is bred in the southern part of the central Pyrenees and Languedoc-Roussillon regions; it is the hardy meat cow of the Pyrenees. Accustomed to living in severe conditions, the Gascon breed is exceptionally rugged and can support itself by grazing on the poor vegetation of sheer and rock-covered mountains. It has thus attracted the attention of English, Scottish, Czech, and South American breeders.

The cuisine of the Gascon region has long been famous, and the quality of Gascon beef plays an important role in this reputation.

GASCON AREOLE

p. 200

(also Mirandaise)

Origin: Gers, France; herd book established 1894
Distribution: Regional
Population: 200 cows in France
 (in conservation)
Weight of bulls: 1,760–2,310 pounds;
 of cows: 1,210–1,540 pounds
Color: White to gray

In the past the Gascon Areole, or Mirandaise, was prized for its docility, strength, powerful legs, and resistance to heat, which made the breed indispensable for the difficult job of plowing heavy earth on hillsides. Like other breeds of southwestern France (the Blonde d'Aquitaine and Bazadais), the Gascon became a specialized meat breed when draft animals were no longer needed. The Gascon Areole branch of the breed is renowned for its excellent fertility and the quality of its milk.

Threatened with extinction by the changes brought about in farming in the Gers over the past thirty years, the breed today is carefully protected with a view to conserving its genetic material.

HEREFORD p. 25

Origin: England; U.K. herd book
 established 1846
Distribution: International
Population: Large numbers in many countries
Weight of bulls: 2,090 pounds;
 of cows: 1,320 pounds
Color: Red and white

A native of Herefordshire, a region in the west of England on the Welsh border, the Hereford breed was until the 1970s the most widely used in the world for the production of meat, and, whether used as a pure-bred or as a crossbred, the Hereford remains today the basis for many herds of beef cattle raised on ranches in the large cattle-raising countries. The Hereford was introduced into France in 1975, but its development there remains limited.

Relatively large in size, Hereford cattle have a very characteristic color pattern: red with a white head. Hardy, with excellent maternal qualities, the cows nevertheless produce only moderate amounts of milk. They can thrive on mediocre food conditions and can adapt readily to different climates, which is why they became very popular throughout the western United States, for example, in the nineteenth century. Easy to fatten, the cattle flourish especially in extensive grazing lands.

JERSEY (also Jersiais) pp. 87, 255

Origin: Isle of Jersey; U.K. herd book
 established 1878; French herd book 1903
Distribution: International
Population: 5,000,000 cows worldwide
Weight of bulls: 1,320–1,540 pounds;
 of cows: 770–880 pounds
Color: Fawn or fawn and white

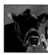

The Jersey breed has been selectively bred for many years for its dairy production. It is known for its small size, delicate bone structure, tough hooves that can tolerate rugged terrain, and a solid or pied color that ranges from very light to dark fawn. The French Jersey (Jersiais) is raised mainly in western France, where the total population is about 5,000, but the Jersey breed is very popular around the world, where there are an estimated five million head. The breed has also been used in many tropical countries for improving the local stock. The Jersey's main attribute is its milk which is rich in protein and has a high cream content; she is called the "most buttery" of all dairy cows.

LIMOUSIN

pp. 92, 231, 276

Origin: Limoges region, France;
 herd book established 1886
Distribution: International
Population: 800,000 cows in France
Weight of bulls: 2,200–2,860 pounds;
 of cows: 1,430–1,870 pounds
Color: Bright wheat

Famous for its excellent meat, the Limousin breed is from the Limoges region, which is predominantly grazing country with difficult climatic conditions in winter that have, over the centuries, forged the hardy characteristics of the breed. In recent decades, the Limousin has been developed well beyond its home region. In France alone, the number of head has increased by fifty percent in fifteen years. Abroad, the Limousin is used as a purebred and in crossbreeding in sixty-four countries on five continents. This expansion can be explained by the fact that this breed of meat cattle offers an attractive combination of butchering advantages as well as maternal qualities. The Limousin thus makes it possible to obtain a wide range of finished products from animals of all ages, from the young calf to the aged cow. Limousin beef is especially lean.

LONGHORN

p. 205

(also Texas Longhorn)

Origin: England; U.K. herd book
 established 1878
Distribution: Great Britain, United States
Population: 2,000 in Great Britain
Weight of bulls: 2,200 pounds;
 of cows: 1,450 pounds
Color: Black, red, or brown and white

Longhorn cattle can be recognized by their large horns, which turn down in a sweeping curve; their dark hide with lighter flecks; and a white dorsal stripe. A native of Yorkshire, the Longhorn was very popular in centuries past, expanding into the Midlands, England's West Country, and Ireland. The calves, which are raised for meat, adapt readily to pasture grazing. Nevertheless, the total numbers of Longhorn today have greatly decreased.

The Longhorn was exported to North America over four hundred years ago and, thanks to its hardiness and aggressive nature, was eminently suited to life on the range. It was by far the most important as well as the first breed in America, where it is called the Texas Longhorn, but its numbers declined seriously about 1900 with the advent of breeds that grew faster and were more productive. The breed was saved from extinction by an active conservation group, partly for its historic significance and partly for its genetic diversity.

MAINE-ANJOU pp. 211, 212

Origin: Loire Valley, France;
 herd book established 1908
Distribution: Regional, United States, Canada
Population: 70,000 cows in France
Weight of bulls: 2,420–3,190 pounds;
 of cows: 1,650–1,870 pounds
Color: Red and white

The Maine-Anjou is the product of a cross made in the nineteenth century between the Mancelle, a hardy dairy breed, and the Durham-Shorthorn, an early maturing English meat cow. The breed, raised for both milk and beef, was exported to Canada in the twentieth century and is now raised in the United States as well.

There are 70,000 head of Maine-Anjou cattle in France, seventy percent of which are raised in the Loire Valley. The breed has recently been introduced into major farms in the Nord-Pas-de-Calais, Champagne-Ardennes, Normandy, Brittany, and Poitou-Charentes regions of France, as well as in Belgium. Other exports have been made to Canada, the United States, Russia, Japan, and Oceania.

The breeding effectiveness of the Maine-Anjou is excellent. It is a docile animal, adaptable to large ranching operations, and often gives birth to twins. The Maine-Anjou is also one of the heaviest breeds on the international level: at the 1988 General Agricultural Competition in Paris, a bull named Royal weighed 4,229 pounds; and in 1996 a cow named Campanule weighed 2,895 pounds.

MARAÎCHINE p. 127

Origin: Vendée, France
Distribution: Local
Population: About 130 cows in France
Weight of bulls: 1,980–2,200 pounds;
 of cows: 1,320–1,760 pounds
Color: Light gray to fawn brown

It is believed that the Maraîchine is a descendant of the same Paithenais-Vendéen branch as the Parthenais and Nantes breeds. The Maraîchine allegedly became differentiated through adaptation to the marsh environment from which it derives its name, *marais*. Originally from the central western Atlantic coast, where it grazed in marshy areas, the breed expanded from the Loire to the Gironde Rivers in the nineteenth century before meeting with competition from breeds specialized in dairy or meat production. Today, the Maraîchine is confined to the Vendée marshes, where a dozen breeders have taken steps to keep the breed in its native setting.

The breed is all-purpose, though primarily used in meat production; the cows provide good milk production, and are maternal, hardy, long-lived, and easy calvers. The Maraîchine is known for its ability to feed on rough fodder and by its resistance to disease in wet regions.

MARCHIGIANA pp. 225, 226

Origin: Italy; herd book established 1957
Distribution: Regional (the Marches, Abruzzi)
Population: 200,000 cows in Italy
Weight of bulls: 2,640 pounds;
 of cows: 1,430–1,540 pounds
Color: Light gray

Formerly a draft breed from central eastern Italy, the Marchigiana is known for its very pale gray color and its relatively small size. The breed, which may have been crossed with Chianina and the double-muscled Piedmont breeds, has an extremely good growth rate and is well conformed. It is used today for the production of meat in difficult areas. The population of Marchigiana cattle, although constantly declining, is still satisfactory, with almost 200,000 cows.

MONTBÉLIARD pp. 112, 264

Origin: Franche-Comté, France;
 herd book established 1889
Distribution: International
Population: 670,000 cows in France
Weight of bulls: 2,200–2,640 pounds;
 of cows: 1,430–1,650 pounds
Color: Red and white

A descendant of the Pie Rouge des Montagnes, the Montbéliard breed has benefited from more than a century of selective breeding. Today it represents sixteen percent of French dairy stock. Originating in the Franche-Comté region, the breed has expanded widely throughout most of eastern France and into the Massif Central; it is also found in western France, where its numbers continue to grow. Abroad, the Montbéliard is raised in various European countries, Africa, the Middle East, and America.

First raised in foothills and mountainous areas, the breed produces milk that makes excellent cheese; it feeds on locally gathered fodder. The Montbéliard's milk is used for the production of Comté, Gruyère, and Morbier cheeses, among others. In farming areas, the breed is an excellent dairy cow and also offers fine meat products.

NANTES

p. 85

Origin: Southern Brittany and
 Loire-Atlantique, France
Distribution: Local
Population: About 90 cows in France
Weight of bulls: 1,540–1,870 pounds;
 of cows: 1,100–1,320 pounds
Color: Wheat

Related to the Parthenais and
the Maraîchine, the Nantes breed
is a native of the marshy areas
around the streams and seashores
between the estuaries of the
Vilaine and Loire Rivers. Today it is found solely in
the Loire-Atlantique and survives only because of
breeders' efforts and those of the Grande-Brière
Regional Nature Park.

Like the Maraîchine, Nantes cattle suffered
from competition from specialized breeds, while
offering the same advantages: all-purpose use for
both meat and milk production, hardiness, and good
adaptation to wet areas and a diet of rough forage.

NORMANDE

pp. 66, 107

Origin: Normandy, France;
 herd book established 1883
Distribution: International
Population: 700,000 cows in France
Weight of bulls: 2,200–2,640 pounds;
 of cows: 1,500–1,715 pounds
Color: Black or dark brown and white
 or cream

The Normande breed derives
from an ancient cross between
the cattle that once lived in Nor-
mandy and the animals intro-
duced by Viking conquerors. The
breed is now found in France from the Ardennes
to the Pyrenees and has been firmly established
in Latin America for more than a century, as well
as in Europe, particularly in Belgium, Switzerland,
Great Britain, and Ireland. With 700,000 head of
cattle in France, the Normande has demonstrated
its ability to adapt to pasture operations and to
fairly hot and humid climates.

The Normande is renowned as the great
French dairy breed because of its protein-rich milk
and the excellent cheese it produces. A very large,
all-purpose breed, the Normande is also prized for
its delicious beef, which is remarkably tender and
well marbled.

PARTHENAIS

p. 252

Origin: Poitou-Charentes, France;
 herd book established 1893
Distribution: Regional
Population: 13,000 cows in France
Weight of bulls: 2,200–2,860 pounds;
 of cows: 1,540–1,980 pounds
Color: Wheat

 The Parthenais is one of the oldest French breeds. The Parthenais Breeders Association was founded in 1893, at a time when there were almost a million head, making it the third largest French breed. Now numbering about 13,000 head of purebred cows (compared with 7,000 in 1987), the Parthenais is raised in the Poitou-Charentes and Loire Valley regions. It is a native of the Deux Sèvres department, while a nucleus is developing in Great Britain and North America, especially Canada.

The Parthenais has specialized as a meat cow for twenty years, although its milk was once used for making butter. Today, the animal is prized for its fertility, maternal qualities, and excellent beef.

PIEDMONT

pp. 69, 241

(also Piedmontese)

Origin: Piedmont, Italy;
 Italian herd book established 1963
Distribution: International
Population: 180,000 cows in Italy
Weight of bulls: 2,530 pounds;
 of cows: 1,430–1,540 pounds
Color: Gray

 A native of the Upper Po Valley, the Piedmont is light gray in color, with a darker area around the bull's neck, and black around the eyes and the tip of the tail. Formerly used as a multiple-purpose breed for milk, beef, and farm work, it is used today, as a purebred or for crossbreeding, solely for the production of meat because of its excellent lean-meat yield. The animal is no longer used for pulling or for its milk production, which was modest. The Piedmont results from the selection and fixation of the gene that produces marked muscular hypertrophy throughout the body. Today, therefore, the breed is highly attractive for crossbreeding, either with dairy cows, as in Holland, or with beef cattle, as in Brazil. The Piedmont has thus been successfully exported to many countries on several continents.

PIRENIACA
(also Pyrenees)

p. 215

Origin: Spain
Distribution: Southern slopes of the Pyrenees
Population: Several thousand
 (in conservation)
Weight of bulls: 2,200 pounds;
 of cows; 1,430 pounds
Color: White

An ancient local breed used for farm work, meat, and milk, the Pireniaca, or Pyrenees, is a white animal with a pale muzzle. Used in the past in mountainous farms, the breed nearly died out along with the old farming methods in these regions; the Pireniaca herds that have remained are currently used for the production of meat in the mountain valleys of the Pyrenees.

PRIM'HOLSTEIN
(also Holstein, Holstein-Friesian)

pp. 88, 91, 176, 179, 186, 235

Origin: Friesian Islands,
 Netherlands; and Holstein, Germany;
 French herd book established 1990
Distribution: International
Population: 2,700,000 cows in France
Weight of bulls: 2,200–2,640 pounds;
 of cows: 1,430–1,650 pounds
Color: Black and white

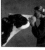

Originating in northern Europe, this Dutch-German dual-purpose breed was established in northern France in the early nineteenth century as the Hollandaise. At the same time, the breed was introduced by Dutch colonists to North America and England, where it was called Holstein-Friesian. In the 1960s French breeders were looking for a cow capable of producing more milk; having selected the Hollandaise for milk production from the beginning, they decided to import bulls, and then semen, from North American Holstein herds. The result of the cross became the French Friesian and then, in 1990, the Prim'Holstein.

The Holstein is the leading dairy breed in the world. Its numbers in France rank French dairy stock second after the United States. Today, the Prim'Holstein is raised throughout France, where it is the leader in milk production. In Argentina, where it is an important dairy cow, the breed is called Argentine Holando.

RETINTA

p. 120

Origin: Spain; herd book established 1933
Distribution: Regional
Population: 130,000 cows in Spain
Weight of bulls: 2,310 pounds;
 of cows: 1,430 pounds
Color: Red

The Retinta is named for its dark red color. A native of southwestern Spain, it has evolved into a typically hardy, quiet animal in response to the climatic conditions of the region. Exceptionally maternal, the Retinta, which was once used for pulling, is today raised for meat production, either as a purebred or as a crossbred, but always in extensive ranches in the difficult areas of southern Spain. Raised on grass in natural conditions, the Retinta's progeny supply meat of very high quality. With 130,000 cows, the Retinta today represents five percent of Spanish dairy stock. Some examples of the breed have been exported to Latin America.

ROMAGNOLA

p. 207

Origin: Central eastern Italy;
 herd book established 1963
Distribution: Regional (Emilia, Marches)
Population: 8,000 in Italy
Weight of bulls: 2,530 pounds;
 of cows: 1,430 pounds
Color: Light gray

An old working breed from the Bologna province in Italy, the Romagnola is recognized by its large size and its color—light gray, with a markedly darker area at the bull's neck, black around the eyes and at the tip of the tail. The modernization of agriculture in its native region has led to a strong decline in the population of this breed; today there are only a few thousand cows, which are used in meat production.

FLAMANDE p. 103
(also Rouge Flamande, Flemish)

Origin: Northern Europe;
 French herd book established 1886
Distribution: Northern Europe
Population: 3,500 cows in France
Weight of bulls: 1,980–2,420 pounds;
 of cows: 1,430–1,650 pounds
Color: Red or black

One of the oldest French breeds, the Flamande belongs to the Breton branch called the Pie Rouge des Plaines. The French breeders' association was founded in 1886 in Bergues. Mainly found in the Nord-Pas-de-Calais region, the Flamande is, nevertheless, raised on several farms in the departments of Somme and Ardennes, and in Normandy.

The Flamande is one of the large-sized specialized dairy breeds. It produces a great quantity of milk, which is also especially rich in protein. At the Paris Agriculture Show in 1935, the cow Victorieuse produced a total of more than 22,000 pounds of milk in three successive animal lactations (average 300 days).

RUBIA GALLEGA p. 247
(also Galician Blond)

Origin: Spain
Distribution: Regional (Galicia)
Population: Limited
Weight of cows: 1,320 pounds
Color: White

The Rubia Gallega is from a mountainous region of typically very small farms. White with a pale muzzle, the breed was traditionally one of versatile abilities: farm work and meat and milk production, although it was used mainly for milk. There has been a large population in the past, but the modernization of farming has led to the replacement of these cattle by more productive dairy breeds such as the Holstein. Thus, the Rubia Gallega today is mainly used for its beef, which is produced in a meat-production operation.

SALERS

Origin: Cantal, France;
 herd book established 1908
Distribution: International
Population: 175,000 cows in France
Weight of bulls: 2,200–2,750 pounds;
 of cows: 1,430–1,650 pounds
Color: Mahogany red

 The Salers is a very old breed from the Massif Central and was originally used as a draft animal and for the production of such renowned cheeses as Cantal. Today, only ten percent of the cows are used for milk; the rest are raised in meat-production operations. From its native region in the departments of Cantal, Puy-de-Dôme, and Corrèze, the Salers breed has been scattered throughout France, with excellent herds in new regions such as Normandy, Picardy, Champagne-Ardennes, and Lorraine. Likewise, because of their excellent breeding characteristics, Salers cattle have been introduced to twenty-five countries on the five continents, particularly into areas of extensive cattle raising: North America, Australia, and Eastern Europe.

In addition to her great maternal qualities, the Salers cow is known for excellent fertility and longevity. A hardy breed, it also produces famously grained and marbled beef, which consumers consider a great delicacy.

SHORTHORN

Origin: Northeastern England;
 U.K. herd book established 1822
Distribution: International
Population: 4,000 in Great Britain;
 20,000 in United States
Weight of bulls: 2,090 pounds;
 of cows: 1,320 pounds
Color: Red and white; solid red

 The Shorthorn is one of the most famous breeds of cattle. Selected by English breeders beginning in the eighteenth century, it was used in all the cattle-raising countries in the nineteenth and early twentieth centuries in order to improve meat production—especially for conformation and rapid growth—in other breeds existing at the time. Because of the diversity of selection objectives, two branches gradually became separated: the Beef Shorthorn meat animal, which became by far the most widely distributed in the world; and the dual-purpose Milking Shorthorn, which was also exported, notably to the United States, Australia, and Russia. Although the Shorthorn was the most prevalent breed in most of the large beef-producing countries in the early twentieth century, it has steadily declined in population since that time, to such an extent that today many countries have implemented programs to preserve the breed.

FRENCH SIMMENTAL

pp. 95, 161, 194

(also Simmental Français,
Pie Rouge de l'Est)

Origin: Eastern France;
 herd book established 1930
Distribution: International
Population: 35,000 cows in France
Weight of bulls: 2,200–2,640 pounds;
 of cows: 1,540–1,720 pounds
Color: Red and white

With forty million head of cattle worldwide, the Simmental belongs to the Pie Rouge des Montagnes group. The breed is found on the five continents and is known in Britain as the Pimpernel Simmental; in Switzerland as Simmental; in Germany and Austria as Fleckvieh; and in Italy as Pezzata Rossa. The French Simmental is a dual-purpose dairy cow, raised largely in eastern France. Today it is expanding into the grazing areas of the Massif Central and into the department of Aveyron, in connection with the reestablishment of Laguiole cheese. Along with its outstanding milk production, the French Simmental is also popular with butchers for its lean meat. The muscular animal is also used in France in several beef-production operations, a common practice in North America. The French Simmental adapts to all climates, but it is especially successful on grazing farms because of its ability to feed on great quantities of rough fodder.

TARENTAISE

pp. 47, 249

Origin: Savoie, France;
 herd book established 1888
Distribution: Regional
Population: 14,000 cows in France
Weight of bulls: 1,650 pounds;
 of cows: 1,100 pounds
Color: Fawn

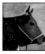

The Tarentaise is named for the high mountain valley in Savoie where it was first bred. Today the breed in France is raised in the Alps and the Massif Central, but because of its world-renowned hardiness, the Tarentaise is also raised in twenty-one countries on four continents, either for the production of milk, as in the Mediterranean Basin, Africa, and Asia, or of meat, as in North America and Oceania.

The Tarentaise, a remarkable dairy cow, is often raised in difficult conditions: in summer, it grazes in unsheltered mountain pastures as high as 7,500 feet, while in winter it feeds exclusively on hay. The cow's milk is balanced, rich in protein, and excellent for making the cheeses with which its name is associated: Beaufort and Reblochon, both of which bear the *Appellation d'Origine Contrôlée* label of high quality, and Tomme de Savoie. Because it has evolved over time in the rugged mountains of Savoie, the Tarentaise is also known for its outstanding advantages in cattle-raising operations, such as its excellent adaptation to grazing in difficult conditions and to climate variations, its efficient use of rough fodder, and its longevity. Indeed, the Tarentaise is the cow for difficult areas.

Sheep (*Ovis aries*)

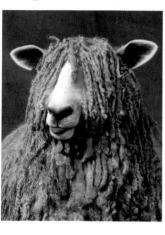

Origin: Lombardy, Italy;
 flock book established 1976
Distribution: Regional
Population: 30,000 ewes in Italy
Weight of rams: 185–210 pounds;
 of ewes: 165–185 pounds
Color of fleece: White; of head: White

The Bergamasca breed, native to the alpine provinces of Lombardy, is now spreading throughout northern Italy. These sheep, the basic breed of the lop-eared Alpine group, are very large, with distinctively drooping ears. They are often raised in seasonally migrating herds and are suitable for wool and meat production; in intensive lamb-production operations, ewes may lamb three times in two years. They are the foundation of many other breeds.

BLUE MAINE p. 141
(also Bleu du Maine)

Origin: Northwestern France;
 flock book established 1927
Distribution: France, Germany, United Kingdom
Population: 47,000 ewes in France
Weight of rams: 240 pounds;
 of ewes: 175 pounds
Color of fleece: White; of head: Blue

 Bleus du Maine are native to the region between the Maine-et-Loire and the Mayenne and Sarthe Rivers. Like Western Reds, the Blues are the result of a cross between rams of English Wensleydale and Leicester longwool blood and ewes of the local, now extinct Choletais breed. Some of the progeny of this cross have a blue-black color on the face, hence the name Bleu du Maine; Western Reds are so called for their copper-red heads. The largest populations are today in lower Normandy, in the Loire region, and in Champagne.

CAUSSES DU LOT p. 143
(also Caussenard du Lot)

Origin: Lot, France; flock book established 1955
Distribution: Regional
Population: 130,000 ewes in France
Weight of rams: 180–220 pounds;
 of ewes: 120–145 pounds
Color of fleece: White;
 of head: Black and white

 The Causses du Lot breed belongs to a large group of the hardy southwestern breeds. Raised chiefly in the department of Lot, the sheep are well adapted to being raised either outdoors or in confinement, and they are often moved in flocks of three hundred to six hundred ewes.

Causses du Lot are either raised as purebreds, for their excellent maternal qualities (fertility, good milk production, hardiness, and especially their ability to breed in all seasons), or they are crossbred with rams of meat-producing breeds for lambs with better conformation. Crossing Causses du Lot ewes with Île de France rams results in lambs that satisfy the market's demand for *fermier du Quercy* lamb.

CHARMOISE pp. 169, 191

Origin: West-central France;
 flock book established 1927
Distribution: Regional
Population: 20,000 ewes in France
Weight of rams: 120 pounds;
 of ewes: 100 pounds
Color of fleece: White; of head: White or pink

This breed is named for a farm in the department of Loir-et-Cher, where, in the mid-nineteenth century, English Kent rams were mated with ewes born from crosses of Solognote, Berrichon, and Merino in order to create a breed that would combine their meat- and wool-production properties. The Charmoise is the basic breed of west-central France, especially in areas where it is difficult to raise grazing lambs, and in south and southwestern France. This breed of sheep has also been exported to Germany, England, Ireland, and Spain, where it does well in poor pasture.

The Charmoise is either used as a purebred, or it is crossbred in order to pass along its exceptional conformation, its tendency to lamb late in the season (which means greater economy for the breeder, who needs to provide less silage), and hardiness.

CLUN-FOREST p. 167

Origin: United Kingdom; U.K. flock book
 established 1925; French flock book 1970
Distribution: International
Population: 1,000 ewes in France
Weight of rams: 190–220 pounds;
 of ewes: 130–155 pounds
Color of fleece: White; of head: Black

Native to the Clun Valley in Shropshire, the area of southwestern England next to Wales, Clun-Forests have been selectively bred in Great Britain since 1837; they were introduced into France in 1960, although they are not as numerous in France as they are across the Channel.

Clun-Forests are a hardy breed, with a good meat-producing conformation, and they can manage under fairly difficult conditions with acid soil and a relatively harsh climate. Accustomed to grass, the breed is completely adapted to being raised outdoors or partially outdoors. The breed's good growth performance and the ewes' good maternal qualities explain why, in its native country, the Clun-Forest is often kept as the base female in crossbreeding projects.

CORRIEDALE p. 145

Origin: New Zealand
Distribution: International
Population: Large
Weight of rams: 220–645 pounds;
 of ewes: 175–220 pounds
Color of fleece: White; of head: White

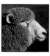

Corriedales are the result of cross-breeding in the late nineteenth and early twentieth centuries in New Zealand, between Australian ewes and Lincoln and Leicester longwool rams. The aim of the cross was to combine the wool-producing properties of the Merino with the breeding qualities of British sheep. Corriedales are hardy animals that adapt perfectly to countries with extensive sheep ranching, and they are the second most significant wool producer after the Merino. Thus they can be found in North and South America, China, Japan, Russia, and Oceania.

DELLE LANGHE p. 63
(also Langhe)

Origin: Southern Piedmont, Italy;
 flock book established 1974
Distribution: Regional (northern Italy)
Population: 15,000 ewes in Italy
Weight of rams: 170–200 pounds;
 of ewes: 140–155 pounds
Color of fleece: White; of head: White

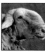

The Delle Langhe is a breed of large sheep, with white fleece and head. It is native to northwestern Italy, but a few flocks also appear in Emilia-Romagna. Today the breed is raised for its milk production: the ewe can produce as much as fifty-three gallons of milk in a single lactation (average 270 days).

HAMPSHIRE
p. 65

(also Hampshire Down)

Origin: England; U.K. flock book
established 1889; French flock book 1957
Distribution: International
Population: 5,000 ewes in France
Weight of rams: 200–230 pounds;
of ewes: 145–155 pounds
Color of fleece: White; of head: Black

Hampshires, native to England, were introduced into France and North America in the late nineteenth century, but the breed was not really developed in France until the mid-1960s, where it is now well established in northern Picardy and Normandy and in the eastern and Auvergne regions, although breeding rams are used well beyond these areas. French Hampshires are regularly exported to Europe, South Africa, Brazil, the Antilles, and elsewhere.

The Hampshire breed combines the rapid growth rate and excellent conformation of the meat-producing breeds and the early maturing and fertile qualities of the grazing breeds. These animals convert forage into meat and fiber very efficiently and easily regain condition after lambing.

IDEAL
p. 145

Origin: Argentina
Distribution: South America
Population: Moderate
Weight of rams: 200 pounds;
of ewes: 155 pounds
Color of fleece: White; of head: White

Ideals are crossbred sheep, created in South America in the late nineteenth century by crossing English longwool breeds with Merino ewes. At the time, the longwool-Merino cross was widespread in many countries, aiming to combine in a single breed the meat-producing and reproductive qualities of the British animals with the wool-producing and adaptive capacities of the Merino. The breeds used in South America to produce Ideals were also used in the same period by the Australians to obtain the Polwarths, which are thus equivalent to the Ideals.

INRA 401 p. 175

Origin: France
Distribution: National
Population: 30,000 ewes in France
Weight of rams: 200 pounds;
 of ewes: 145 pounds
Color of fleece: White; of head: White

Produced by crossing Romanovs, Finns, and Berrichons du Cher and the best results of those crosses, the INRA 401 resulted from an INRA (Institut National de la Recherche Agronomique) research project of the 1960s. The breed tends to be concentrated in the southern half of France, where sixty-two percent of the population is raised, but there are also substantial numbers in the cereal-growing areas of the north. The INRA 401 population is estimated at 30,000 ewes, in operations that range from small farms to large ranches. The breed is also found in England, Spain, and Portugal.

INRA 401s have exceptional maternal qualities, produce an average of two lambs per lambing, and demonstrate the ability to reproduce year-round. The breeding of rams with good meat-producing qualities to INRA females results in larger lambs.

LACAUNE p. 129

Origin: Massif Central, France;
 flock book established 1947
Distribution: Regional
Population: 1,290,000 ewes in France
Weight of rams: 200 pounds;
 of ewes: 155 pounds
Color of fleece: White; of head: White

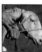

This breed is named for the Lacaune hills in the Tarn region, where it originated. With well over one million ewes, the Lacaunes constitute by far the largest population of any French breed of sheep. Lacaunes were originally bred for milk production to make Roquefort cheese, but after a few years part of the Lacaune population was selected to produce lambs for meat production, so that today there are two distinct breeds: Lacaune Milks, with 750,000 ewes, and Lacaune Meats, with 540,000 ewes. Both breeds are well suited to pasturage, because they are so hardy, but animals raised for milk production are usually confined during the winter. Lacaunes are now found well beyond the breed's birthplace, in many regions of France, but they are also exported to a number of other countries for their milk and meat production.

LINCOLN p. 144

Origin: Lincolnshire, England;
 flock book established 1892
Distribution: International
Population: 1,000 ewes in England
Weight of rams: 265–310 pounds;
 of ewes: 176–220 pounds
Color of fleece: White; of head: White

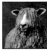

Lincolns, one of the British long-wool breeds, are very large animals. They have an excellent growth rate and good conformation, and they are very hardy and well adapted to open-air living, even in difficult climates. The Lincoln breed has thus been used a great deal in crossbreeding to improve local populations. Lincolns are found in most of the major sheep-farming countries, including Australia and New Zealand; South America, in particular, Argentina and Patagonia; North America, Russia, and China.

AUSTRALIAN MERINO pp. 59, 152

Origin: Australia
Distribution: Australia
Population: Millions of ewes
Weight of rams: 175 pounds;
 of ewes: 110 pounds
Color of fleece: White; of head: White

Australian Merinos result from the importation, beginning in the late eighteenth century, of Spanish Mérino animals that came to Australia either directly from Spain or from other European countries (Germany in particular) and North America. These animals have been selected principally for wool production; their fleece is characterized by very long locks and very fine fiber (twenty to thirty microns). We can identify several types within this vast population: the medium-wool type, also known as "Pépin," which is the most numerous; the fine-wool type, farmed chiefly in Tasmania; and the coarse-wool type, which is raised more in the north and west of Australia.

RAMBOUILLET pp. 146, 256–59
(also Rambouillet Merino)

Origin: Spain
Distribution: Regional
Population: 100 ewes in France
Weight of rams: 175 pounds;
 of ewes: 110 pounds
Color of fleece: White; of head: White

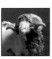

The ancestors of this extra-fine-wool Merino sheep were imported to France from Spain under Louis XVI, in 1786, after a few attempts beginning in 1750. Since the eighteenth century, the Rambouillet Merino breed has been used to improve French flocks and has contributed to the establishment of new breeds, such as l'Île de France and Berrichon du Cher. Because they adapt to all climates and all diets, Rambouillets also contributed to the formation and improvement of flocks, between 1830 and 1850, in the major wool-producing areas, such as Australia, North and South America, and Eastern Europe. Today, as a result of competition from the great wool-producing countries, such as Australia, and too much variation in the wool, this breed has practically disappeared. The one flock left in France belongs to the Bergerie Nationale (national sheepfold) located in Rambouillet, southwest of Versailles.

PORTLAND p. 208

Origin: Southern England;
 flock book established 1973
Distribution: Local
Population: 1,000 ewes
Weight of rams: 110 pounds;
 of ewes: 90 pounds
Color of fleece: White; of head: White

Portlands, native to southern England, are characterized by the presence of horns on the ewes as well as the rams. The breed, which is very rare today, was used to develop the Dorset breed. Its lambs are very small and are born red, gradually lightening in color as they mature.

RAÏOLE

p. 197

Origin: Cévennes, southern France;
 flock book established 1980
Distribution: Regional
Population: 1,400 ewes in France
Weight of rams: 180 pounds;
 of ewes: 130 pounds
Color of fleece: White; of head: White

The horned Raïole breed is part of the large family of southern European milking sheep breeds called the Caussenardes du Larzac or the Caussenardes des Garrigues. Aware of the homogeneity and the advantages of this group, some breeders established in 1980 a syndicate of Raïole breeders. The breed is distributed throughout Cévennes, a mountainous region of steep-sided valleys and very limited pasturage. The search for well-conformed animals has led to a diminution in the number of ewes (11,000 in 1958 but only 1,400 in the 1990s).

The Raïole is a hardy breed that makes possible the development of natural zones essentially intended for use by sheep. Good walkers, the ewes take advantage of the local roads of Cévennes and move during the summer into the foothills of Mount Aigoual. The year-round breeding capacity of the Raïole has made late-summer lambings possible. A dozen flocks are now being used in a revival program sponsored by nature parks in Cévennes and Grands Causses.

ROMANOV

p. 173

Origin: Russia
Distribution: International
Population; 15,000 ewes in France
Weight of rams: 190 pounds; of ewes: 130
Color of fleece: White with black hairs;
 of head: Black and white

Natives of Russia, Romanovs were first imported into France in 1963, as an INRA experiment; in 1970, a second introduction was undertaken in order to increase the birthrate of certain meat-producing breeds and thereby the productive capacity of French flocks. Today the Romanov breed population is estimated at 15,000 ewes, which are located in the intensively used cereal-growing regions of the northern half of France.

Besides being exceptionally prolific, Romanovs have great milk production and a very well-developed maternal instinct. The animals also engage in sexual activity all year long, which permits every type of breeding operation.

The crossing of the Romanov breed with the meat-producing Berrichon du Cher resulted in the INRA 401 breed.

ROUSSIN p. 117

(also Rouge de Hague)

Origin: Northwestern France;
 flock book established 1983
Distribution: Regional
Population: 10,000 ewes
Weight of rams: 210 pounds;
 of ewes: 145 pounds
Color of fleece: White; of head: Red-brown

Roussins resulted from crosses between local Norman sheep and the English Dishley and Southdown breeds. This regional breed, which emerged in the eighteenth century in the dunes and barrens of northern Manche, received an infusion of English blood about 1920, in order to develop the type and improve meat production. A few infusions of Suffolk blood also took place, at a later date. Today Roussins can be found in western France.

Rather large, hardy sheep, Roussins are a pasture breed that is well adapted to the ocean climate, with its rains and winds. They are low-maintenance animals and make the most of poor-quality pasture as well as rich meadows. The lambing season of the flocks, which usually number fewer than fifty ewes, takes place in winter, after December 15.

SHROPSHIRE p. 51

Origin: England; flock book established 1883
Distribution: Hills of west-central England
Population: 1,000 ewes in England
Weight of rams: 265 pounds;
 of ewes: 200 pounds
Color of fleece: White; of head: Black

Shropshires are medium-sized sheep, with short, white wool that covers their entire body, except for the head and feet, which are black. They are raised in hilly areas and produce high-quality lambs with good conformation. The origin of the breed is not certain, but it is known that the Southdown was used to breed out coarseness and horns and that the Leicester and Cotswold breeds were used to improve wool and body size. Shropshires are raised worldwide, from North America to Australia and New Zealand. It was the most popular and influential breed of wool-producing sheep in the United States from the late nineteenth century until the 1940s, when it declined in numbers until English Shropshires were imported to improve American stock.

SOLOGNE

p. 155

(also Solognote)

Origin: Central France
Distribution: Regional
Population: 3,000 ewes in France
Weight of rams: 175 pounds;
 of ewes: 120 pounds
Color of fleece: Gray-brown;
 of head: Brown-red

Solognes are an ancient breed, taking its name from its birthplace, the Sologne region, to which it was adapted and where, beginning in the fifteenth century, it made the peasants' fortunes. Around 1850 the population was very numerous (300,000 head); today it remains an unusual breed that is protected because of its particularly interesting characteristics. The breed is also found in the neighboring departments, in the barrens of Brittany and Gascony, and in Burgundy and Dauphiné. A few animals are exported to Germany, Belgium, the Netherlands, and Morocco.

Solognes are a very hardy breed, both in their resistance to disease and in their ability to thrive on sparse and woody vegetation, even under the most difficult conditions. They are especially sought after as a means of utilizing the underbrush, barrens, and firebreaks produced on poor and difficult soils.

SOUTHDOWN

pp. 19, 273

Origin: South of England; U.K.
 flock book established 1892;
French flock book 1947
Extent: International
Population: 1,000 ewes in England;
 2,000 in France
Weight of rams: 175 pounds;
 of ewes: 130 pounds
Color of fleece: White; of head: Gray

Native to the south of England, the Southdown is a breed that has long been raised in France: it was, in fact, on the occasion of the 1855 Exposition Universelle in Paris that the Comte de Bouillé imported the first sires into France, to Villars in Burgundy. Beginning with the English "close to the ground" type, certain breeders have selected for animals that are taller and heavier. At one time the Southdown was one of the most populous breeds raised in France (196,000 head in 1932 and 600,000 in 1963). Since then the numbers have steadily diminished because the animals are somewhat too small to produce, even in good conditions, the heavier carcasses that are more economical to process.

Southdowns are raised in many countries; in France they are found primarily in the Auvergne, Limousin, and Poitou-Charentes regions, as well as in the departments of Côte d'Or, Indre, and Cher. The rams are used in crossbreeding because of the good Southdown conformation; grass-fed lambs are sent to market in summer. In recent years the breed has been exported to Great Britain (to strengthen local populations), Italy, Spain, Northern Ireland, Belgium, and Indonesia.

SUFFOLK

p. 52

Origin: England; U.K. flock book
established 1887; French flock book 1957
Distribution: International
Population: 40,000 ewes in France
Weight of rams: 240 pounds;
of ewes: 165 pounds
Color of fleece: White; of head: Black

This native English breed resulted from eighteenth-century cross-breeding between Norfolk Horned ewes and Southdown rams. Breeding stock was first introduced into France and America in the late nineteenth century. Suffolks have also been exported to the five continents; today France is an important exporter. During the 1960s French breeders made an effort to select a heavier, more prolific animal, better adapted to continental and Mediterranean climates. At present the French population of this breed is established chiefly in the north and east, the Poitou-Charentes region, and the southwest.

Suffolks, which graze but can also be raised in confinement, are either marketed as purebreds, highly valued for their maternal qualities, fertility, milk production, and hardiness, or they are crossed with any number of other breeds, because their rapid rate of growth and good conformation produce heavy lambs without excessive fat.

THÔNES AND MARTHOD

p. 267

(also Thônes et Marthod)

Origin: Savoie, France
Distribution: Local
Population: 2,500 ewes in France
Weight of rams: 165 pounds;
of ewes: 130 pounds
Color of fleece: White; of head:
Black and white

The Thônes and Marthod seems to be one of the Mediterranean breeds of sheep, a hypothesis supported by the history of Savoie, which once belonged to the kingdom of Piedmont and Sardinia. This rare breed is to be found chiefly in the departments of Savoie and Haute-Savoie, in the valley of the upper Maurienne River, and in the Thônes region.

The principal qualities of these sheep are their great hardiness, their fertility, and their good milk production. Their stamina allows them to graze in even the highest mountain pastures, where they spend three to four months a year in perfect freedom, almost without supervision, subject to dramatic and abrupt variations in temperature. When the ram remains with the flock permanently, the ewes lamb an average of three times every two years. The breed is crossbred for meat production but is also milked for excellent cheeses.

VENDÉE

p. 111

(also Mouton Vendéen)

Origin: Vendée; flock book established 1967
Distribution: Regional (Atlantic coast)
 and in England
Population: 250,000 ewes in France
Weight of rams: 220 pounds;
 of ewes: 155 pounds
Color of fleece: White; of head: Gray

 The Vendée breed results from the improvement, in the late nineteenth century, of a local population by crossbreeding with English Southdowns and by selecting for the ability to thrive in a climate of very hot summers and very humid periods. Vendéens display good maternal qualities (fertility, good milk production, and maternal instinct), as well as good growth potential and excellent conformation, all of which explain why they are used both as purebreds and for crossbreeding.

The population of about a quarter of a million ewes is distributed chiefly throughout the Loire and Poitou-Charentes regions and in adjoining areas. For some years the breed has been exported to Great Britain, Italy, Spain, Northern Ireland, Belgium, and Indonesia.

Acknowledgments

I do not claim to have produced this book alone, and I wish to thank most warmly all who agreed to participate in the project and who gave me their time and their friendship so that I might present here my favorites of the many photographs I have taken.

I will mention first two very dear friends—Claude Lahaye of CENECA, which administers the Salon International de L'Agriculture in Paris, and Jean-Louis Larivière of Ediciones Larivière, who made it possible for me to shoot in Argentina for the book *Arte Rural*, which he published. I am also very grateful to Philippe Achache, of the Impact Agency, who played an important role in organizing the photography at the Royal Show in London.

The following list may be incomplete, so if I have omitted anyone, I ask your forgiveness in advance. Many people helped bring this volume into being, with both friendship and efficiency, and I am thankful to all of them for their well-informed, sympathetic, and skillful assistance.

In France: CENECA (the Salon International de l'Agriculture), Paris, especially Claude Lahaye and Señora Martinez-Muñoz; the Haras du Pin; the organizers of the Lessay Agricultural Fair; the Bergerie National in Rambouillet, especially Antoine Brimboeuf; Pierre del Porto of SOPEXA; and Alain Raveneau, author of the text of the book *Bestiaux*.

In England: The R.A.S.E. (Royal Agricultural Society of England) organizing committee of the Royal Show, London, especially Miss E. S. Binions, Royal Show livestock executive; Viki Mills, for organizing a splendid "pig day," and, of course, Jeremy Hunt.

In Argentina: Dudú von Thielmann of Ediciones Larivière, Buenos Aires; the members of the Sociedad Rural Argentina, and its president, Enrique C. Crotto, as well as Mercedes Villegas de Larivière, Marina Larivière, Mariano G. Fernández Alt, Antoinette Huffmann, and Enrique

Baserga for their generosity and hospitality; Colette Larivière, Buenos Aires; Josefina and Ricardo Mathó Garat, of the estancia La Estrella; and Sara, Susana, and Emilio Jorge Ferro, of the estancia La Adela (Península de Valdés). They all contributed to the making of *Arte Rural*, Ediciones Larivière.

In Italy: Associazione Italiana Allevatori, Rome, including its general manager, Fortunato Tirelli, and in particular Andrea Giuliani; as well as the organizing committee of the Verona Fieragricola.

Among the many individuals who contributed to this lengthy project, I would like to thank most especially Françoise Jacquot for all the talent and enthusiasm that she conveys to the actors in these photographs; as well as Marc Lavaud, Isabelle Lechenet, Franck Lechenet, Jean-Philippe Piter, Jean-Paul Thomas; and Franck Charel, Stéphan Christiansen, Gaël Cotonnec, Thomas Gogny, Olivier Jardon, Dominique Llorens, Antonio Lopez-Palazuelo, Bérangère Monguillon, Kamel Ouadi, Stéphane Rabaud, Nicolas de Vries, and Lionel d'Avignon. I also wish to thank Philippe Gueugnier, of Car Away, for lending us the trailer that we use as our office and that allows us to work under excellent conditions every year; and the du Ronchay textile mill, in Luneray, for making our awnings.

The photographs for this book were taken with a Mamiya 6 x 7 camera, Godard flashes, and Kodachrome, Ektachrome, and Fujichrome film.

A big thank-you to the whole crew at DPE (Mamiya, France), and most especially to Francine Muller; to everyone at Godard; and to Rush-Labo for developing our film so quickly and for their messenger service.

Some of the photographs in this book were originally published in *Bestiaux*, Éditions du Chêne (1991), and *Arte Rural*, Ediciones Larivière (1995).

YANN ARTHUS-BERTRAND

Index

The numbers in *italics* refer to pages in the last section of the book that contain facts pertaining to the individual breeds.

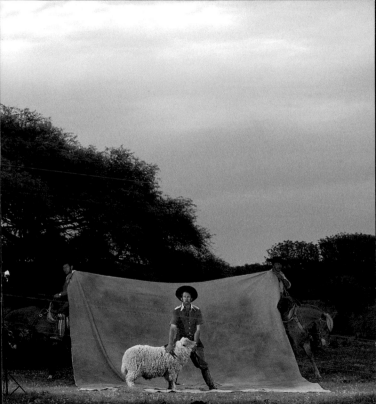

TEXTS ON THE VARIOUS BREEDS were written by Jacques Bougler (INA-PG); Nicolas Baudoin (Institut du Cheval); Philippe Desbois (France UPRA Sélection); Stéphane Patin (France UPRA Sélection); and Éric Abraham (France UPRA Sélection). Assistance with the English text was provided by Glenn Selk of Oklahoma State University and Pierre del Porto of SOPEXA.

TRANSLATED FROM THE FRENCH BY
Anne Norris, Alexandra Bonfante-Warren, and David J. Baker

CAPTIONS FOR PHOTOGRAPHS ON SUPPLEMENTARY PAGES:
Pages 2–3: **CHAROLAIS COW,** Une de Mai (daughter of Superbe and Frivole), seven years old, shown by Alain, son of the breeder, Élie Rousseau, of Bizeneuille, France
Page 4: **ARGENTINE PETISO PONY, WELSH TYPE,** Ocho Sardina (daughter of Ocho Rincón), belonging to Juan Luciano Miguens, of Buenos Aires, Argentina (La Rural, Buenos Aires)
Page 280: **AUXOIS HORSE** (detail of hindquarters)
Page 296: **ARDENNES STALLION** (detail)
Page 344–45: **CRIOLLO HORSE** on the Pampas, Argentina.
Page 350–51: **SHEEP,** 50 Percent Corriedale and 50 Percent Ram, on the Pampas, Argentina.

Editor, English-language Edition: Gail Mandel
Design Coordinators, English-language edition:
 Miko McGinty and Rita Jules
Production Manager, English-language edition:
 Diane Sahadeo

Library of Congress Control Number:
2002114940

ISBN 0-8109-9066-0

Copyright © 2000
Éditions de La Martinière, Paris
English translation © 2003
Harry N. Abrams, Inc.

Published in 2003 by Harry N. Abrams,
Incorporated, New York.

All rights reserved. No part of the contents of this book may be reproduced without written permission of the publisher.

Printed and bound in Italy

10 9 8 7 6 5 4 3 2 1

Harry N. Abrams, Inc.
100 Fifth Avenue
New York, N.Y. 10011
www.abramsbooks.com

Abrams is a subsidiary of
LA MARTINIÈRE
G R O U P E